IMAGES
of America

CHAMPAIGN

On the cover: In the early 1900s, a group of four children gathered around a Harris Ice Cream wagon for a special treat on a hot summer day. This charming photograph was made along Hill and Randolph Streets near the old Champaign high school not far from West Side Park. (Courtesy of the Champaign County Historical Society.)

IMAGES
of America
CHAMPAIGN

Raymond Bial

ARCADIA
PUBLISHING

Copyright © 2008 by Raymond Bial
ISBN 978-0-7385-5188-3

Published by Arcadia Publishing
Charleston SC, Chicago IL, Portsmouth NH, San Francisco CA

Printed in the United States of America

Library of Congress Catalog Card Number: 2007938998

For all general information contact Arcadia Publishing at:
Telephone 843-853-2070
Fax 843-853-0044
E-mail sales@arcadiapublishing.com
For customer service and orders:
Toll-Free 1-888-313-2665

Visit us on the Internet at www.arcadiapublishing.com

This book is lovingly dedicated to my wife, Linda, with whom I have made a home in Champaign-Urbana for 30 years.

Contents

Acknowledgments 6

Introduction 7

1. The Early Years: Before 1865 9

2. Years of Growth: 1865–1890 19

3. Coming of Age: 1890–1920 37

4. A Bustling City: 1920 to Present 93

Acknowledgments

This book would not have been possible without the generous support of the Urbana Free Library Archives staff, including director Anke Voss and the following staff: Carolyn Adams, Norma Bean, and Karla Gerdes. The archives not only provided ready access to their priceless holdings of historical photographs and those of the Champaign County Historical Society, but the staff also diligently looked up photographs and provided key research information on many of the subjects in this book over the course of many months. The Urbana Free Library Archives is truly one of the finest institutions in the twin cities.

INTRODUCTION

As one walks around the vibrant city of Champaign, one glimpses the globes of old streetlamps, stately mansions settling back in the shade, and at least a few charming brick streets that have not been paved over. One cannot help but wonder how people in this community lived in the past—50 years ago, 100 years ago, and even more than 150 years ago when Champaign was just a depot stop on the Illinois Central Railroad. And one of the best ways to become acquainted with the past is through a photographic history of the community, such as *Champaign*.

But why assemble of a book about only Champaign? Why not a history of the twin cities, and what about the University of Illinois? As I began working on this book, as I had with a previous book entitled *Champaign: A Pictorial History*, I asked myself these questions and several others, since both cities and the university are intertwined economically, socially, and culturally. Yet, since its early days as "the Depot" or "West Urbana," Champaign has prospered with its own bustling downtown and its own municipal government, including the police, fire department, and public library, along with schools, churches, and businesses. Champaign has enjoyed its own history as a community, just as Urbana and the university have their distinctive identities.

On a practical level, it would simply be impossible to put together an adequate photographic history of both communities and the university in a single volume. So, as I had done with the earlier photographic history several years ago, it was decided to again concentrate on the single city of Champaign. Much of the material in this book is drawn from *Champaign: A Pictorial History*, which has been out of print for a number of years. Even then, *Champaign* provides only a sampling of the people, institutions, and events that have shaped the colorful history of the community. Yet hopefully this book offers enjoyable glimpses and insights into the past for those who have made their home in Champaign.

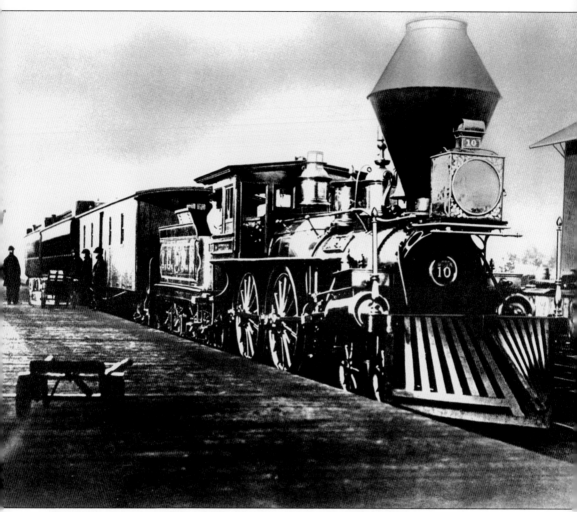

The first locomotive pulled into West Urbana on July 24, 1854. It featured a towering smokestack and prominent, bristling cowcatcher, similar to this engine photographed in 1858. From the beginning, the arrival and departure of steam trains became a regular occurrence in the community for more than a century, before diesel engines replaced the old locomotives.

One

THE EARLY YEARS
BEFORE 1865

The history of Champaign actually began in Urbana when Runnel Fielder raised a log cabin on the edge of Big Grove. Shortly thereafter, William Tompkins erected a cabin near the site of the Courier Building. In 1833, Sen. John Vance introduced a bill to create Champaign County with Urbana as the county seat. Other settlers homesteaded in the county, notably Henry Sadorus, who became the first permanent settler of European descent after Fielder and Tompkins moved on. However, most settlers preferred the area around Urbana. Then, in 1850, Pres. Millard Fillmore approved a land grant for the Illinois Central Railroad. Four routes were considered, but ultimately a route two miles west of Urbana was chosen. In July 1854, the first locomotive chugged up to the depot that was informally known as West Urbana.

The community around the depot grew so rapidly that no one is sure of the first business or its founding date. In 1854 or 1855, John C. Baddeley opened a store, and by 1858, at least 30 businesses, three mills, Boyden's Plow and Wagon Factory, and a local newspaper had already sprung from the prairie to serve a population of 3,285 people. Much of the business district, including the Cattle Bank, was then located on the east side of the tracks around First Street and University Avenue.

Curiously, the tract of land around the depot was laid out parallel to the tracks. By following the railroad line, while the rest of the city was oriented north-south and east west, the slant of several streets around the depot remains a headache for motorists and city planners to this day. While pigs wallowed in the muddy streets, concerts were held in Bailey's Hall and folks attended services at Goose Pond Church on the northwest corner of First Street and University Avenue. The other significant building was the Doane House, a hotel for railroad passengers and workers.

Over in Urbana, folks viewed the growth of the commercial district around the depot with alarm. Officials sought to quickly incorporate the area, but West Urbana became a separate city and even took the name of the county. Urbana residents then worried that Champaign might want to become the county seat, but the new community was content to become the premiere city in the county.

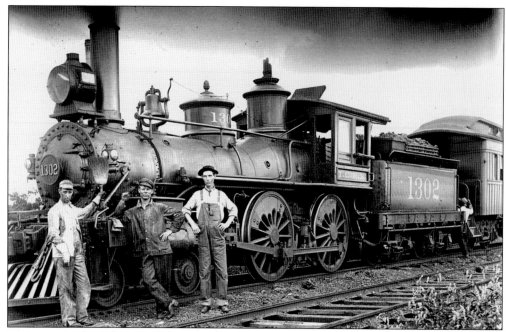

Beginning in the 1850s, wood-burning locomotives and then coal burners, like the one pictured here, hauled passengers and freight to and from Champaign every day. This locomotive is typical of those of the Illinois Central Railroad that regularly eased to a stop at the depot from the late 1800s to the early 20th century, until replaced by diesel engines.

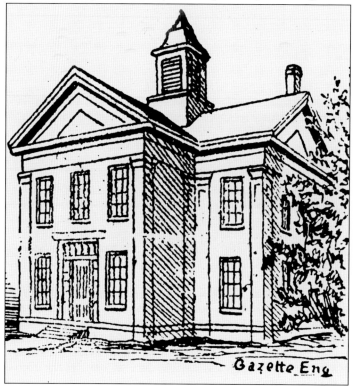

As the railroad brought wealth to Champaign, the city grew and needed more schools. Erected in 1855, "Little Brick," portrayed here in a line drawing, became the first school located west of the railroad track. An impressive three-story building called West Side School, or "Big Brick," later replaced this school on the present site of Central High School at a cost of $80,000.

Among the first homes in Champaign, as depicted in sketches from the 1858 city map, were those of J. P. White, Alonzo Campbell, A. S. Patten, J. S. Wright, J. C. Kirkpatrick, John Mills, and Mark Carley, who was one of the first city supervisors. Built in 1854, the Carley home stood on the on the northeast corner of Church and Randolph Streets. It was torn down to make way for a Piggly Wiggly grocery, which was later replaced by a local restaurant.

Although swaybacked and tumbling down in this old photograph, the Goose Pond Church once served as an active social and cultural institution in early Champaign. The oldest church in town, it was constructed on land donated by the Illinois Central Railroad at the northwest corner of First Street and University Avenue. Abraham Lincoln once appeared at the church during his unsuccessful bid for the U.S. Senate.

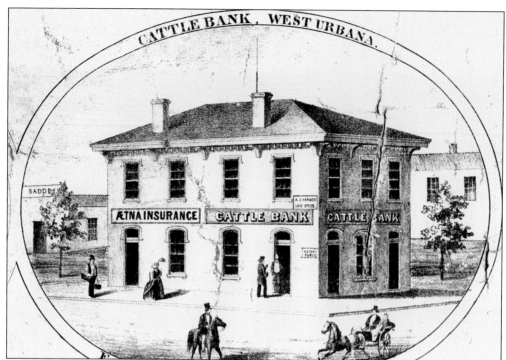

The first bank in West Urbana, the Cattle Bank, a branch of the Grand Prairie Bank, was located on the northeast corner of First Street and University Avenue. Its name suggests that herds of cattle not only grazed in Texas, but also on the prairie surrounding Champaign. In 1865, the Cattle Bank moved its operations to the First National Bank and the building was then used to produce mineral water. Carefully restored, the Cattle Bank remains one of the most recognizable old buildings in Champaign.

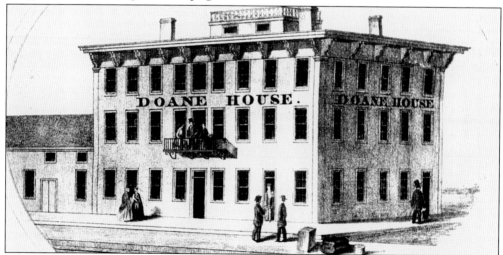

Early West Urbana enterprises featured in the 1858 city map include Pratt and Brothers, Bailey's Hall, and Angle's, which formed part of the business district west of the railroad tracks. A three-story frame building, the Doane House served as both hotel and passenger house for the Illinois Central Railroad. Completed in 1856, it became one of the most significant landmarks in the city until it was destroyed by fire on July 12, 1898.

Opening in 1854 at the corner of East Main and First Streets, the first school in West Urbana was housed in this small wood-frame building. It shared space with the reception room of Dr. R. W. Shoemaker, whose wife taught in the school. Originally there were two school districts in town, known as East Side and West Side. Separated by First Street, these districts combined in 1890.

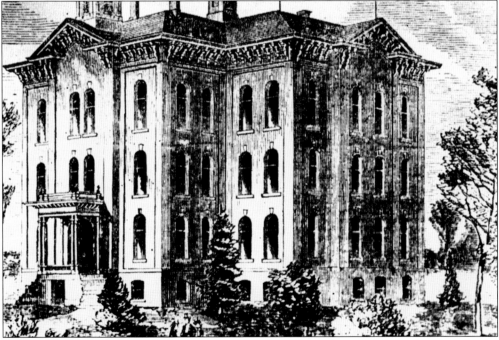

Erected in 1855, "Little Brick" became the first school located west of the railroad track. An impressive three-story building called West Side School, or "Big Brick," shown here, replaced that school on the present site of Central High School at a cost of $80,000. A historian claimed, "One more complete in all its appointments, in rooms, finish, and furniture cannot be found in the West." Sadly, the school was destroyed in an 1893 fire.

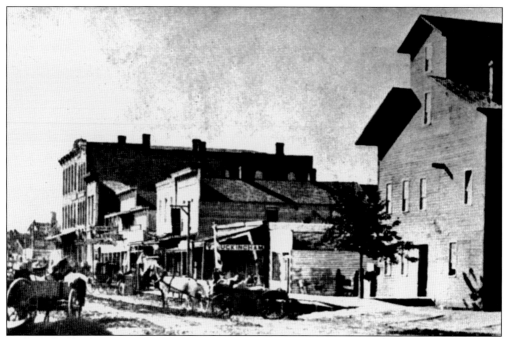

Taken between the late 1850s and early 1860s, these two very early photographs of downtown Champaign depict the Angle Building and a line of other wood-frame structures with false fronts and wooden plank sidewalks. Back then, the town often flooded because the city was built on such low ground. So the high sidewalks not only facilitated the loading of horse-drawn wagons but also offered some relief from the frequently muddy streets. With its storefronts, unpaved streets, and horses and wagons, Champaign looks more like a frontier town of the American West than a budding metropolis on the prairie.

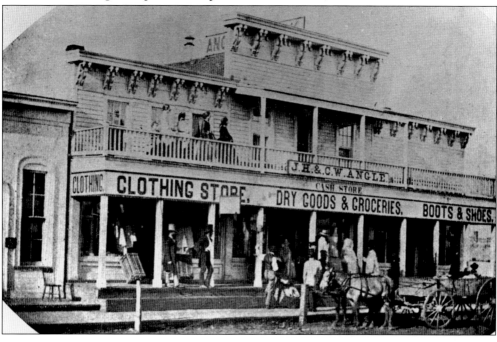

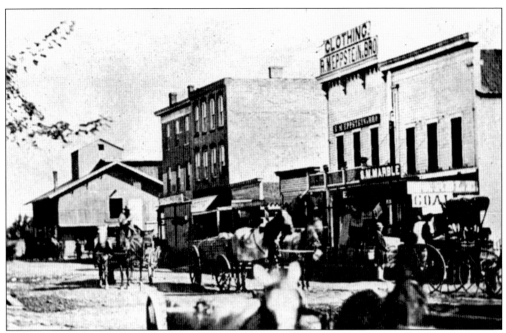

These photographs of Main Street taken about 1860 and 1865, respectively, offer rare glimpses of early city life—and an era that would quickly vanish, largely because of mud and fire. J. F. Hessel wrote in a newspaper article, "West Urbana has paddled its own canoe, unaided and alone. It crawled out of the mud and the mire of early days." Downtown was gradually filled until it rose to a higher grade and became less susceptible to flooding. However, the wood-frame buildings could not survive a number of fires, notably the fire of July 4, 1868, which wiped out nearly an entire block bounded by Main and Taylor Streets on the north and south and Market and Walnut Streets on the east and west. Brick buildings then replaced the wood-frame structures.

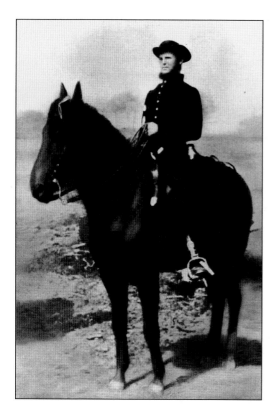

During the Civil War, Anthony Coyle saw action in several campaigns and was wounded five times. However, over three years of service with the Illinois Cavalry, both he and his sturdy horse, Crusher, survived this epic conflict. Coyle returned to Illinois and lived the rest of his days on a family farm near Penfield.

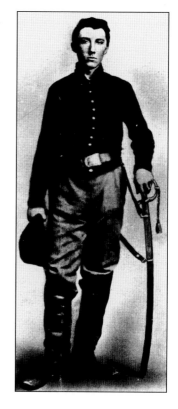

Stephen Alfred Forbes became a captain in Company B of the 7th Illinois Volunteer Cavalry. Forbes not only survived this bloody war, but he also went on to a varied and distinguished career as a well-known scientist. His life's work culminated in his appointment as head of the Illinois State Laboratory of Natural History at the University of Illinois.

This illustration depicts Samuel Alschuler making a photograph known as an ambrotype of Abraham Lincoln on April 25, 1858, with Judge J. O. Cunningham looking on. Although the photograph was made in nearby Urbana, the young lawyer visited Champaign and even spoke at the Goose Pond Church. After he was elected president, a grand inaugural ball was held at the Doane House, with the festivities continuing through the night.

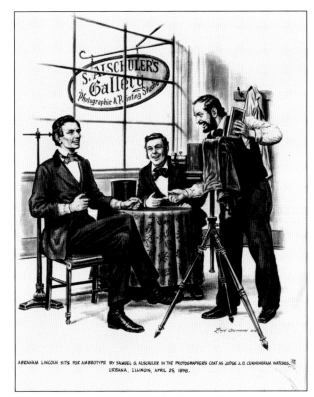

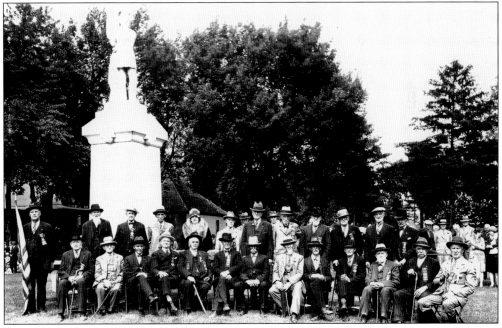

Throughout his presidency, Abraham Lincoln devoted most of his energies to winning the Civil War and preserving the Union. Here a group of veterans of the Grand Army of the Republic from Champaign County who had fought in that defining national conflict gathered for memorial services at Mount Hope Cemetery many years later on May 30, 1928.

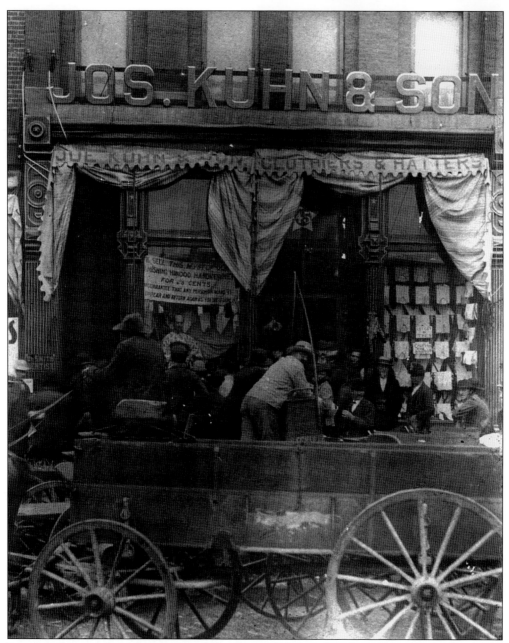

Joseph Kuhn and Son became one of the first and the most enduring retailers in downtown Champaign. Founded in the 1860s as Joseph Kuhn's Clothing Emporium, the business soon became a landmark on Main Street. In this early photograph, customers gathered in front of the store, which promotes a slight of hand artist in the window sign.

Two

YEARS OF GROWTH
1865–1890

The arrival of the railroad became the most significant factor in the growth of Champaign. By 1871, almost 100 miles of tracks had already been stitched across the county, with three lines converging on the city. On November 5, 1887, a *Champaign Daily Gazette* article complained about the "amiable canter" of the Illinois Central trains, but the railroad did shape the second half of the 19th century for the city. Fertile farmland and a new university established in 1867 also enabled Champaign to become a thriving commercial center.

Downtown still struggled with muddy streets and fires. However, by the 1880s, brick buildings were replacing wood structures as Champaign changed from a frontier town to a charming city. Several prominent businesses opened, notably Swannell's Drugstore in 1860 and Joseph Kuhn's in 1865. Opening in 1874, Robeson's became known as the "farmer's store." Along with Kuhn's, it was destined to become one of the most enduring retail stores in downtown Champaign. Joseph Kaufmann Clothiers, W. Lewis Company, and G. C. Willis Store also took root in the latter years of the century.

The city also established key municipal institutions. City hall grew along with the community, with a mayoral-aldermanic form of government—and an unbroken succession of mayors. Police and fire departments were also established, along with public works. City improvements included the Champaign and Urbana Gas and Light Company established by Clark R. Griggs in 1867. William B. McKinley, one of the most resourceful leaders of the time, organized the Western Electric Light Company and eventually consolidated electric, gas, and water services, along with a streetcar system.

In their early years, a number of newspapers served the twin cities, beginning with the *Urbana Union* in 1852, but when the *News* and *Gazette* merged the city had a newspaper that would continue as a prominent local institution over the succeeding generations.

Prosperity in turn led to a flowering of social and cultural life in the city, including women's clubs, fraternal organizations, and literary societies, notably the Champaign Library Association. Established in 1867, this group formed a public library in the Burnham Athenaeum.

Champaign was becoming a pleasant city in which to make one's home. Houses popped up in neighborhoods as rapidly as downtown businesses. The *Central Illinois Gazette* reported, "We note with pleasure the very general disposition of our citizens to plant well our streets with forest trees."

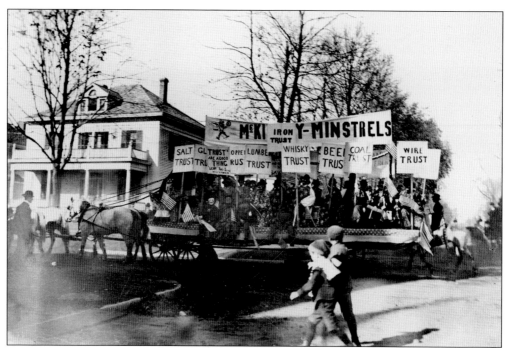

Parades gave people in Champaign a chance to celebrate Labor Day, the Fourth of July, and other special occasions, even visiting dignitaries. Presidential candidates also warranted a parade, as when William B. McKinley visited the city in his campaign for the highest office in the land.

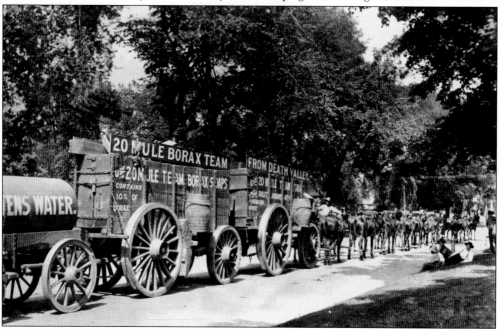

The 20 Mule Team Borax Team, which would later become acclaimed on a popular television show, once made its way in a local parade as onlookers lounged in the shade at the edge of North Street between Church and Park Streets. Undertaken as community events, parades gave people a sense of identity as residents of their hometown.

This early photograph shows the location of Joseph Kuhn's store, which was destroyed in a disastrous fire in 1871. The building had to be torn down to keep the fire from spreading throughout the downtown area. The local enterprise was subsequently rebuilt on the same block and soon opened for business once again.

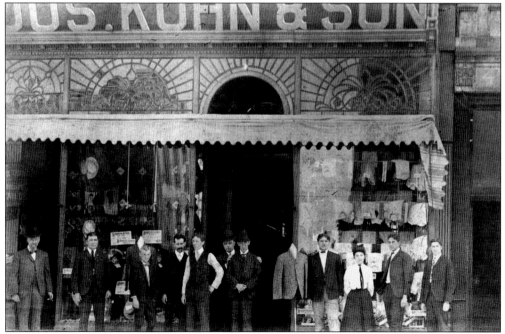

In this photograph taken sometime in the late 1800s, spiffily dressed employees of Joseph Kuhn and Son line the sidewalk in front of the store. Most likely, the portrait was made in the morning, just before the store opened for the day, since the employees appear ready and eager to greet and serve the many customers expected that day.

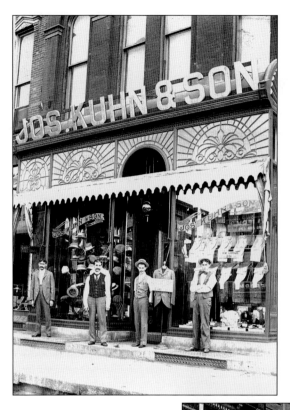

Four well-dressed employees of Joseph Kuhn and Son stand ready to wait on the many customers who will shop at the popular store that day. With an array of merchandise displayed in the window, this undated photograph was likely taken in the early years of the 20th century.

This photograph from the 1960s shows how Joseph Kuhn had changed over the years, while maintaining the same level of quality in serving the people of Champaign. Still located along East Main Street, the enduring enterprise continues to be an integral part of the downtown commercial district.

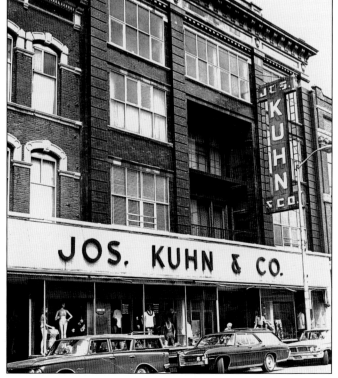

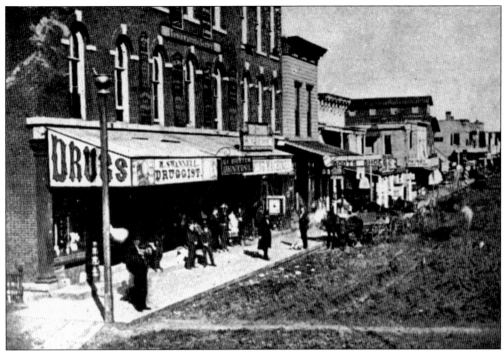

Early on, Swannell's also became a key early enterprise in the downtown area. Champaign still looked like a cow town when the popular store opened in 1860, selling books and stationery on the southeast corner of Main and Neil Streets. A year later, the store moved to the southwest corner. Along with W. C. Barrett, Henry Swannell built the first three-story building the city on the northeast corner of Main and Hickory Streets, but only if the location of the store would be renamed 1 Main Street. To this day, Main Street is the only thoroughfare in Champaign to have odd numbers on the north side.

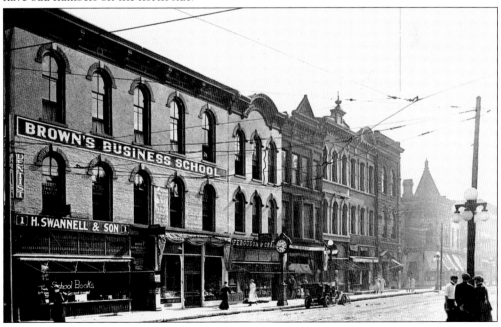

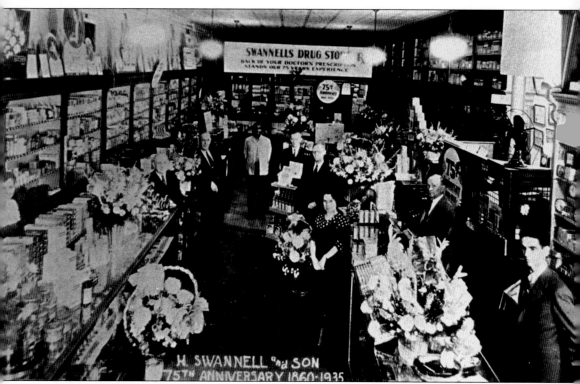

In this vintage photograph taken in 1935, during the depths of the Great Depression, employees of Swannell's gathered to celebrate the 75th anniversary of this local institution. The store not only sold drugs and medicines, but also paints, wallpaper, and a variety of other items. Over the years, the soda fountain at Swannell's became the place to hang out in downtown Champaign. This tradition continued for another 15 years after this photograph was taken, until 1950 when the old Swannell building was torn down to make way for a W. T. Grant store at that location.

Several other drugstores were established in Champaign during the latter half of the 20th century, most notably Cunningham Brothers. Located at 25 Main Street, this enterprise opened its doors in 1880 and quickly became a downtown landmark. For many years, before Campustown sprang up along Green Street, the store catered to University of Illinois students. Taken around 1910, these photographs show both the inviting storefront and the variety of merchandise available within the store—along with owner George Cunningham (below, at right) and employees. The store later moved to the northwest corner of Green and Wright Streets in Campustown.

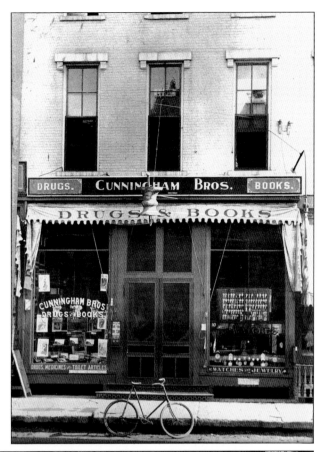

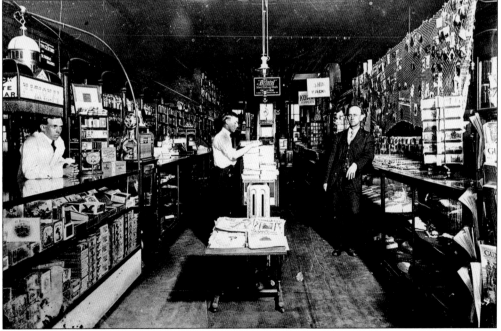

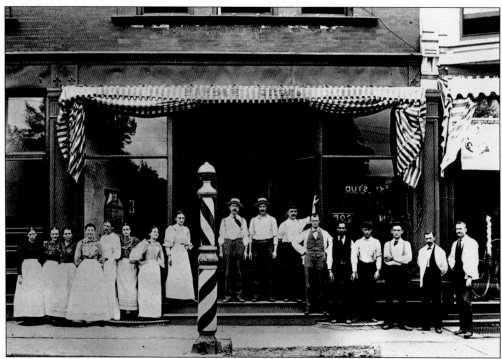

Taken about 1890, these two photographs of an early barbershop located at 122 North Neil Street show the latest fashions of the day as well as the changing face of downtown Champaign, which had already grown into a busy young city. In the above photograph, with barber pole in the foreground, workers lined the sidewalk in front of the local enterprise. In the lower photograph, employees inside the local business stand ready at their barber chairs and other workstations.

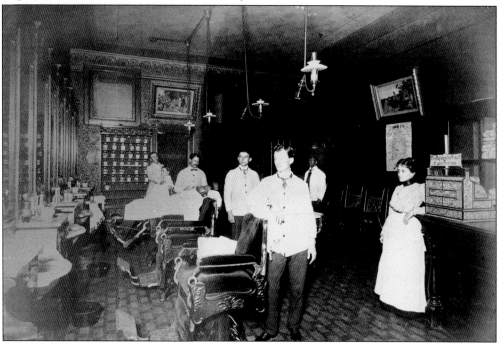

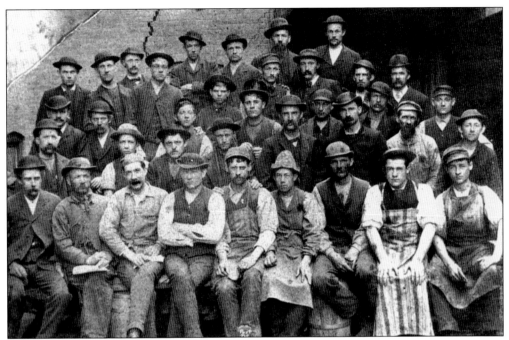

From its founding, Champaign supported several small manufacturing enterprises, including an early furniture factory. Here the hardworking employees gathered for a photograph, including William and Andrew Keusink (second from right in the third row) and Andrew Monroe (fifth from left in the third row). Monroe later opened a steam laundry factory.

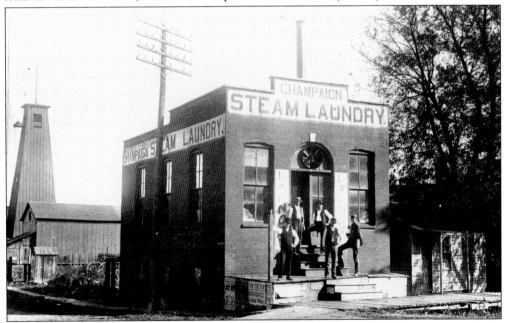

In 1885, Andrew Keusink, along with his brother William and Andrew Monroe, opened the Champaign Steam Laundry when the furniture factory in the background closed indefinitely. Their enterprise became the first steam laundry in town. It did brisk business, especially when it became a full-service operation.

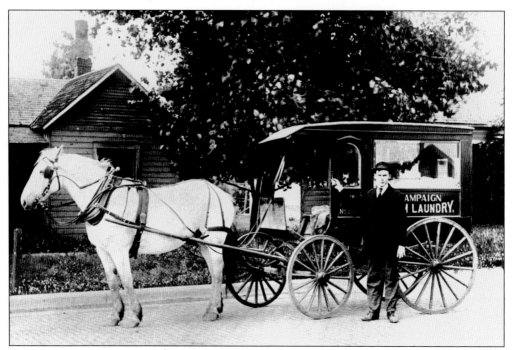

Offering many convenient services as it grew into a thriving business, the Champaign Steam Laundry even began to make pickups and deliveries. In this photograph, Ed Reid, who drove the company's first delivery wagon, posed along with his white horse, which was named Glory.

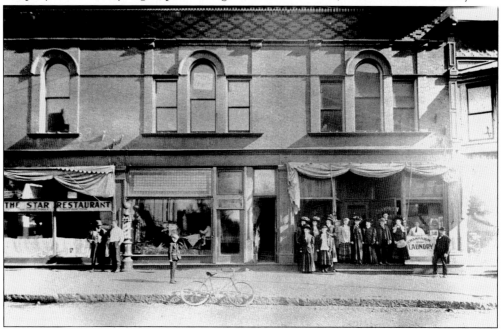

In 1889, the Champaign Steam Laundry moved into remodeled and spacious new quarters that occupied 122, 124, and 126 North Neil Street. In this early photograph, employees took a moment to spread out and pose in front of the new quarters, leaving a glimpse of life in Champaign in the late 19th century.

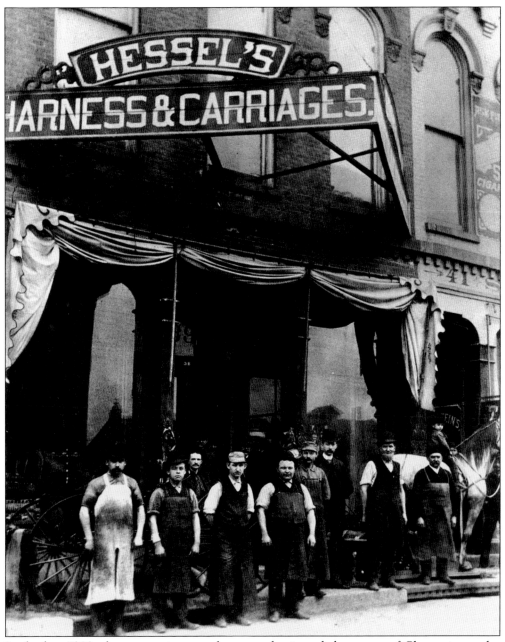

In the late 1800s, horses, carriages, and wagons dominated the streets of Champaign and a number of shops catered to this mode of transportation and delivery of goods. Here a group of sturdy workers posed in front of Hessel's Harness and Carriages in the last years before the first automobiles rumbled upon the scene.

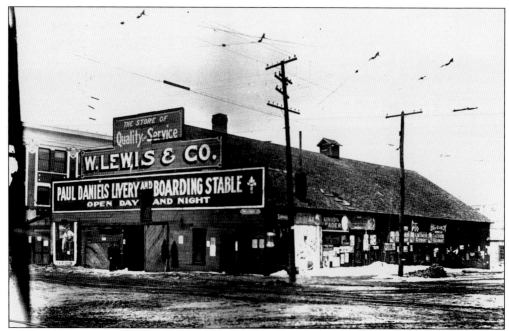

Livery stables, such as Paul Daniel's Livery and Boarding Stable, were once a familiar sight in the city of Champaign—almost as common as gas stations and automobile repair garages are today. This thriving enterprise was once situated on the southeast corner of University Avenue and Walnut Street.

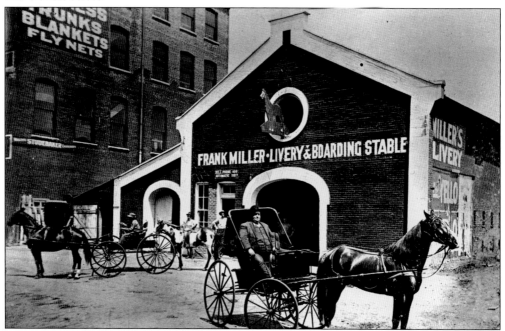

Over the years, Frank Miller Livery and Boarding Stable operated at various locations in the downtown areas of Champaign. In this photograph from the early 1900s, the owner posed proudly with horses, including a pinto in the background, and two carriages in front of his business, which was then located at 48–50 Main Street.

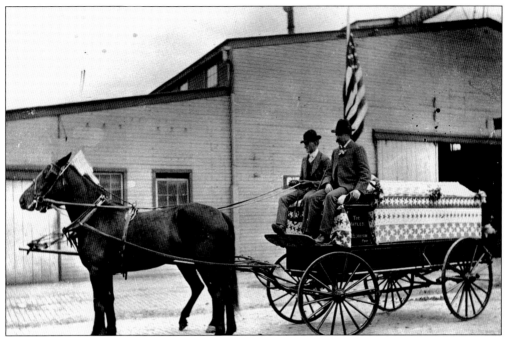

Horses and wagons were not only used to transport people and goods, but they also came into use on special occasions, such as parades. In this unidentified photograph, two men are perched on their horse-drawn wagon in preparation for a parade, most likely in celebration of the Fourth of July.

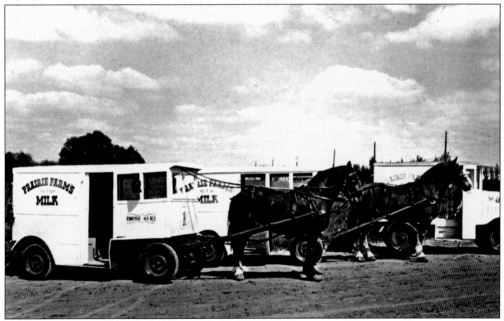

With the arrival of streetcars, the interurban, and the automobile in the late 1800s and early 20th century, horses and wagons were gradually abandoned. However, until the 1940s, Prairie Farms continued to rely on teams of strong horses to pull milk wagons with inflatable tires that resembled trucks.

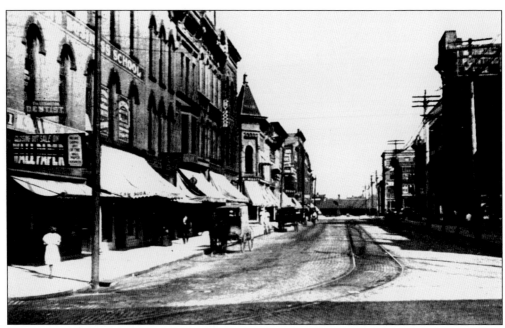

These two early views of Main Street illustrate a growing city in transition. The silver tracks of the trolley line thread their way along the brick thoroughfare. A banner announces a baseball game to be held that day. However, although the First National Bank building stands prominently in the photograph below, automobiles largely remain in the future of the city and the streets are still dominated by horses, carriages, and wagons as people stroll along the sidewalks.

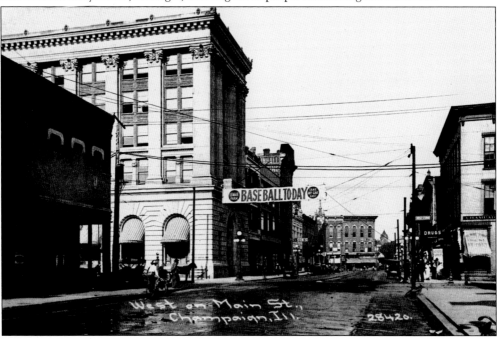

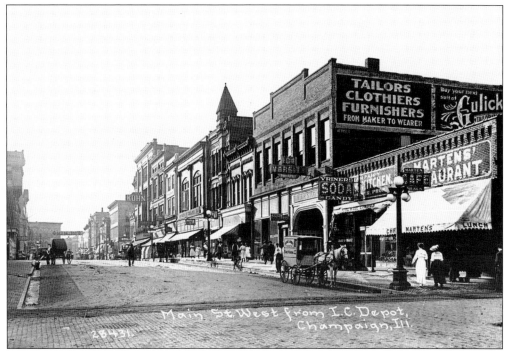

These two photographs provide other rare views of early Main Street. The image above was taken from the railroad depot, looking west, with a horse and buggy parked in front of Vriner's Confectionery and people ambling down the street. Also looking west, the other image taken from an old postcard offers a slightly different vantage point, farther up the street with Cunningham's Drugstore on the near right and Kaufman's department store down the street on the left, with the intersection of Neil Street in the distance.

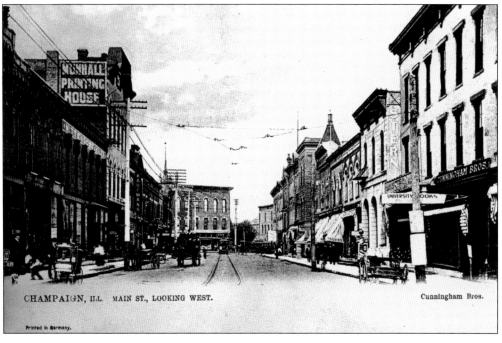

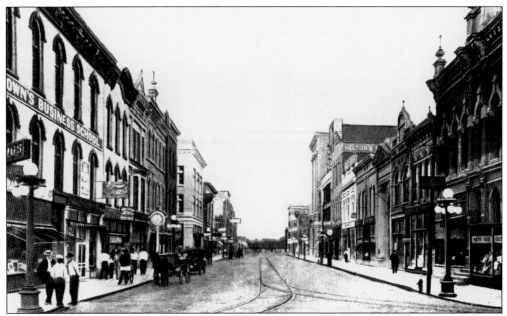

These two photographs illustrate a typical day in the life of Champaign near the corner of Main and Neil Streets. The image above shows Main Street looking east from Neil Street with folks gathered on the sidewalk, a horse and buggy, and an early automobile along with a cluster of globes of streetlights. The other photograph depicts Neil Street looking south from Main and Church Streets with the fountain in the left foreground, the ornate Gazette Building just across the street, and an early streetcar making its way down the middle of the thoroughfare.

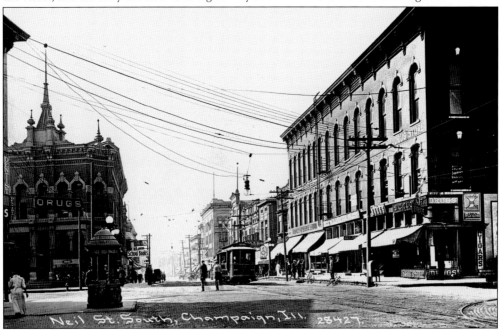

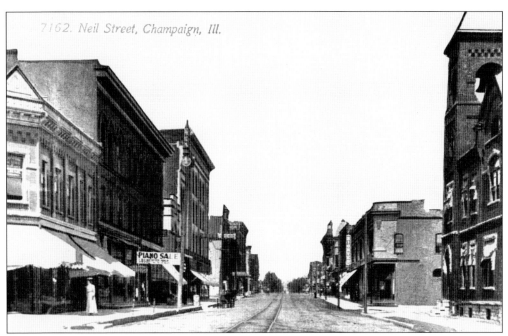

Taken from old postcards, these early photographs provide two other views of Neil Street, looking south, one from a higher vantage point than the other. Looking north, near the city building on the right, the photograph above reveals a quiet street with little going on other than a piano sale at one of the many shops lining the street. Looking south, the photograph below shows the fountain in the foreground and a streetcar making its way around the corner. With a few people gathered on the street, these photographs offer a glimpse of daily life in the city 100 years ago.

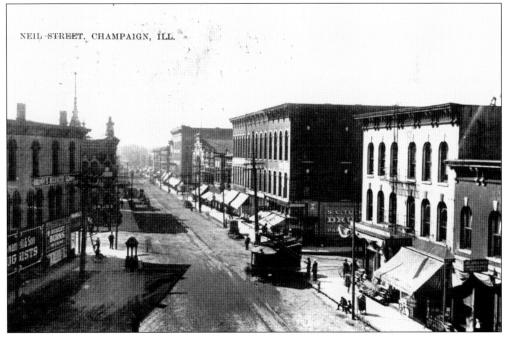

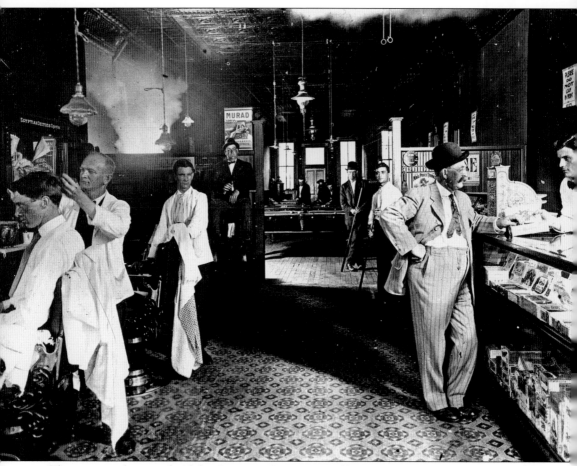

The interior photograph of the Congress Cigar Store offers a rare look at everyday life in the early 1900s. It shows a dapper patron selecting a cigar or two at the glass counter on the right. On the left, one barber clips hair in the style of the day while his colleague waits for a customer. The store also featured pool tables in the back room where customers could amuse themselves.

Three

COMING OF AGE
1890–1920

At the dawn of the 20th century, Champaign experienced further changes because of the railroad. When the Doane House burned in a dramatic fire in 1898, a new depot was constructed. However, this depot was soon outgrown and a grand new station had to be built. The Illinois Central Railroad also constructed underpasses at the key east-west thoroughfares in the city.

Streetcars came to trace the brick thoroughfares. Unlike the smoke-spewing locomotives pulling strings of boxcars or passenger cars, trolleys operated as single cars powered by electricity, a slender arm connecting to the juice flowing through an overhead wire. From 1890 to the mid-1930s, streetcar lines branched throughout Champaign, Urbana, and the University of Illinois campus. One line even cut through the quad. Founded and operated by William B. McKinley, the Champaign and Urbana Streetcar Company gradually extended interurban service to Danville, Decatur, and other cities.

Downtown experienced continued growth. The soda fountain at Swannell's was joined by Vaky's and Vriner's Confectioneries to satisfy the sweet tooth of local folks. First called the Frat Confectionery, Vaky's became an institution on Main Street. Its original name also indicated how often University of Illinois students frequented downtown Champaign to shop for clothes or enjoy a soda at the Frat or other hot spots. At the time there still was no Campustown on Green Street.

People also enjoyed local entertainments such as vaudeville at the Eichberg and Walker opera houses and concerts at West Side Park. Streetcars carried folks to baseball games and other amusements at West End Park, which is now Eisner Park.

The muddy streets of downtown had been paved with bricks, although it would be years before most of the neighborhoods enjoyed such durable surfaces. Utility lines and trolley wires crisscrossed the city as streetcars rattled along. Automobiles would soon begin to putt-putt through town or sit quietly parked among the horses and carriages that lined Main Street.

At its founding, the university had just a few professors and not many more students. By century's end, however, it had already grown to almost 2,000 students with a tremendous economic impact on the city. Social and cultural influences ranged from rallies for football games to speeches in support of women's suffrage. No longer looking to the private colleges of the East, the University of Illinois was finding its own identity as one of the premiere state universities in the nation.

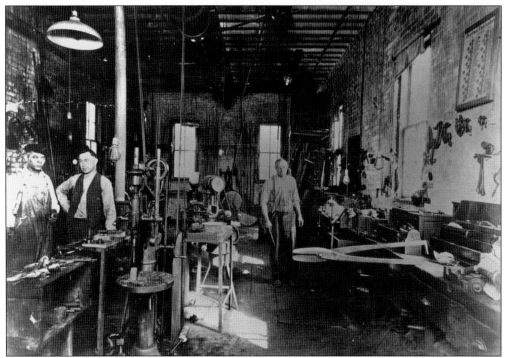

The University of Illinois was not the only business in town, as illustrated in this photograph of Walter Johnson, Forrest Vance, and Wilbur Johnson at work in the Eagle Machine Shop in 1922. This thriving enterprise was located at 337 North Fremont Street in Champaign.

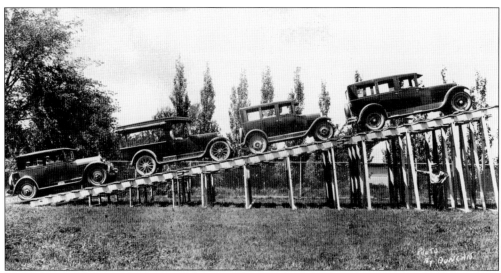

There were other manufacturers in town, as shown in this demonstration of the weight capacity of the first 33-row portable wood bleacher, invented and manufactured in Champaign by the Universal Bleacher Factory located at Neil and Green Streets. This photograph was taken in 1927 with Forrest Vance standing under the bleachers.

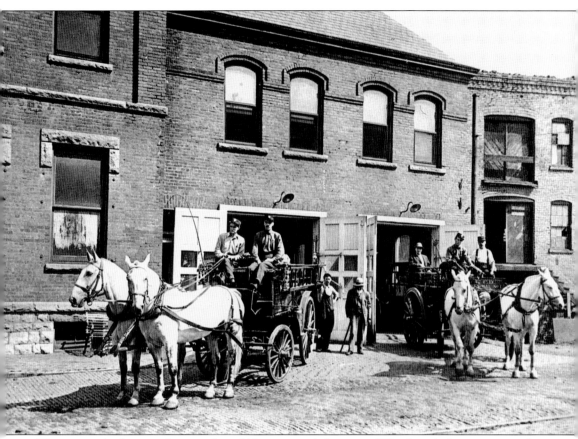

"Our town is built most of pine and would be very easily burnt up. Why doesn't the town council make a move to get up a fir company, a hook and ladder, and a bucket company?" asked a writer in a local newspaper article in 1861. Nearly four years later, on January 15, 1865, the city council authorized a committee to look into the possibility of providing fire service. In April of that year, the city officially placed a hook and ladder wagon, along with four-dozen rubber buckets and three bells. The terrible fire of 1868 prompted the city to acquire a new fire engine and 100 feet of hose. Taken around the beginning of the 20th century, this photograph shows the horses, wagon, and firefighters ready to spring into action.

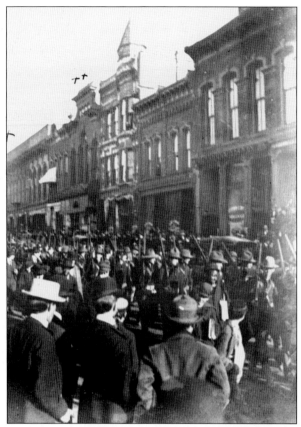

"At the outbreak of the Spanish-American War, in the spring of 1898, Company M of the Fourth Regiment, Illinois National Guard, had been organized for a number of years," wrote Judge J. O. Cunningham in his excellent history of Champaign County. Most of the members of the company came from the twin cities. Here, shouldering their rifles, the men marched past Joseph Kuhn and Son as they prepared to depart in 1898. In the photograph below, the soldiers boarded an Illinois Central Railroad train on a journey that would eventually take them to Cuba. Less than two months later, the Doane House in the background burned to the ground.

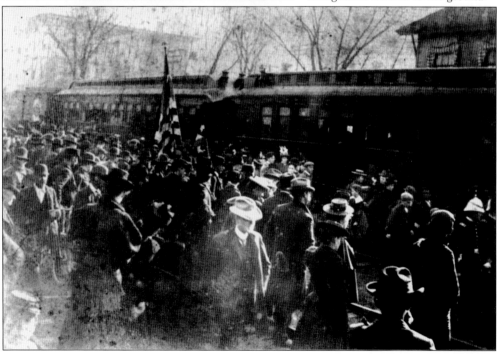

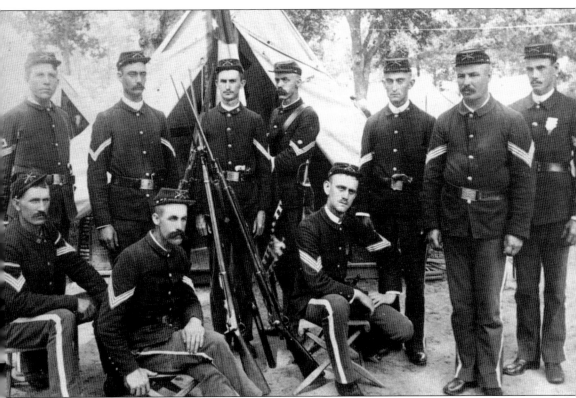

In January 1899, the company went to Camp Columbia near Havana, Cuba, "performing faithfully its duties of guard and camp." The company departed for home on April 4 and was mustered out of service on May 2. The three deaths in the company were Herman McFarland and George F. Turner of Urbana and Perry H. Tittle of Champaign. This photograph of noncommissioned officers of the Illinois National Guard was taken in 1899, just after the end of the war. George Cunningham is the sergeant just right of center.

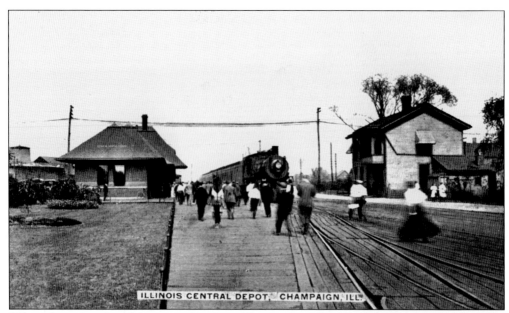

When the railroad track was completed in 1854, the first "depot" was little more than a shack. In 1856, John and Archa Campbell completed the Doane House, which operated as a depot and hotel until the 1898 fire. This *c.* 1900 photograph shows the wide-open spaces around the tracks and the small depot that served the community until the construction of the station that still stands just west of the tracks and north of University Avenue.

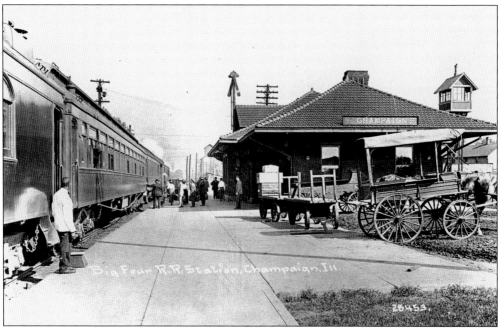

A Big Four railroad station was also located in downtown Champaign—near Neil and Randolph Streets. In this early photograph, a train waited on the tracks for passengers to board with a conductor there to provide assistance. Baggage carts, which were once a familiar sight in American cities, along with a horse and wagon are parked to the right.

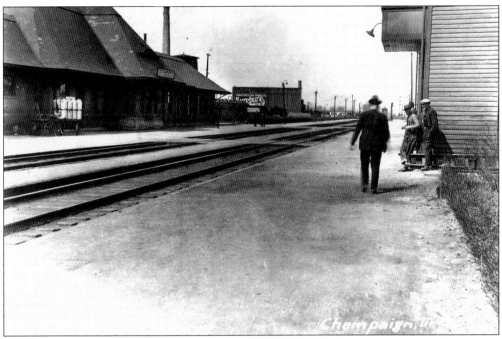

These two photographs offer dawn-of-the-20th-century views of the train station from different perspectives. In one photograph, a man is seen walking along the side of the tracks across from the old station while men hang out at the corner of a building. The other photograph offers an overhead glimpse of the depot and railroad tracks. In both cases, one is offered a sweeping view of the wide-open spaces that once surrounded the train station.

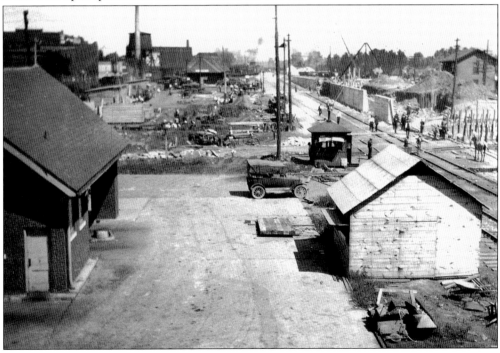

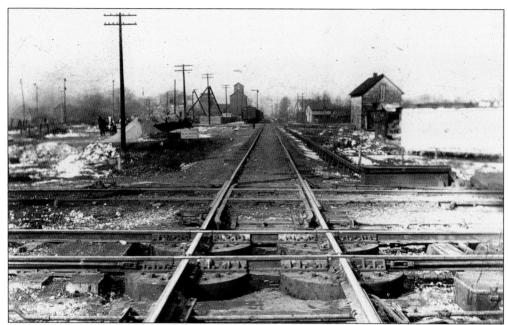

This photograph offers a ground-level view of the railroad tracks that have long crisscrossed the city of Champaign north and south and east and west. However, at this time, in the early 20th century, only a few buildings rose into the skyline around the tracks and a team of horses and a wagon are the only traffic in sight.

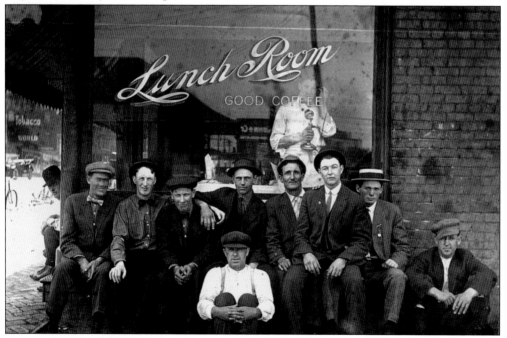

A work gang for the Illinois Central Railroad, including the engineer, fireman, and brakeman, gathered in Champaign for this vintage photograph made in 1912. The rough-and-tumble men were seated in front of a popular lunchroom on the north side of Main Street, across the way from the train station.

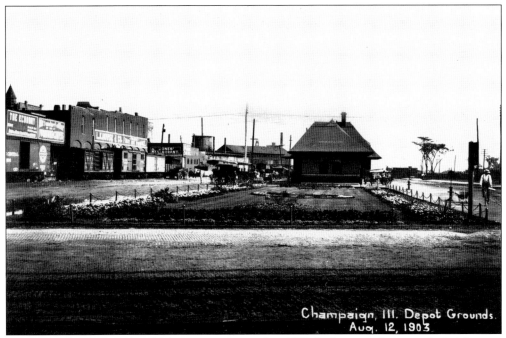

Here is one last look at the old depot as it appeared in 1903, looking north across the brick street on the west side of the tracks, with a man peddling a bicycle on the right. One can also see the array of retail businesses that have sprouted up across the street from the little depot.

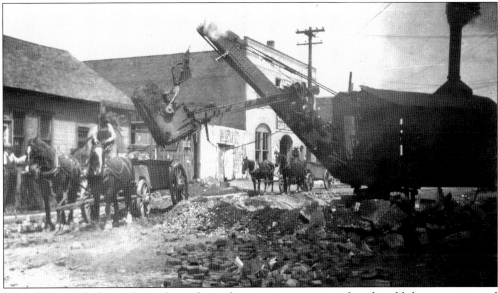

This photograph shows the early work on the new train station after the old depot was moved 114 feet north and placed on a new foundation on July 2, 1923. The spacious new station, including a waiting room, ticket office, and dining room, was dedicated a little more than a year later on August 9, 1924.

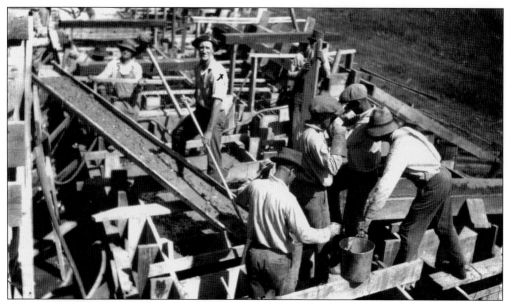

The Illinois Central Railroad not only constructed a grand new station in a nearly two-year period from 1923 to 1924, but the company also constructed underpasses at the main east-west streets in the growing city. In these two photographs, construction workers take a short break from their massive project to pose for the camera amid the scaffolding and girders while they were building the now-familiar and key underpass just south of the train station on University Avenue.

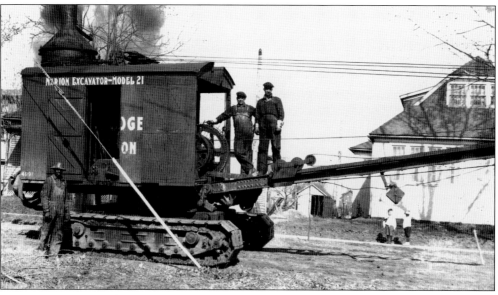

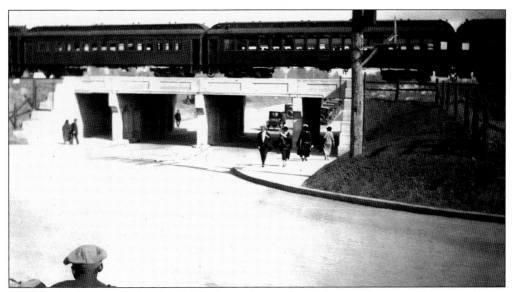

Shortly after it was completed in 1923, the underpass for University Avenue still appeared to be brand new. The first train rumbled over it at 12:01 p.m. on October 16, 1923. This underpass, along with others in Champaign, greatly eased east-west traffic flow at a time when the city was not only growing, but large crowds were also arriving in town to watch football games and take part in other events at the University of Illinois. In the photograph below, now-vintage automobiles are making their way through the underpass, which splits off at Chester Street as well as University Avenue.

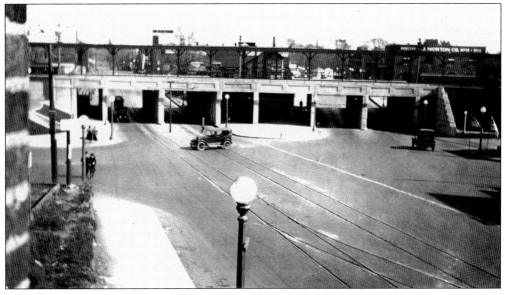

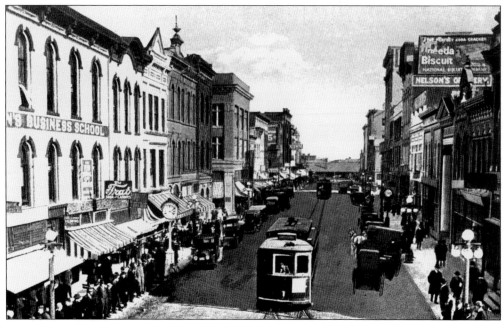

Taken from an old postcard, this glimpse of Main Street, looking east from Neil Street, reveals a bustling downtown. As two streetcars make their way down the middle of the thoroughfare, automobiles and horses and carriages line either side and shoppers crowd the sidewalks. Many of the stores sported awnings to shield pedestrians from the sun and rain.

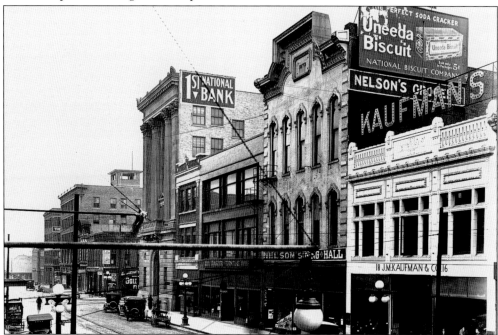

Taken by B. A. Strauch around 1916, this photograph offers a fascinating view of the south side of Main Street, looking east from Neil Street. With automobiles now becoming a familiar sight, the two most prominent businesses in a city coming of age are Kaufman's department store and the First National Bank.

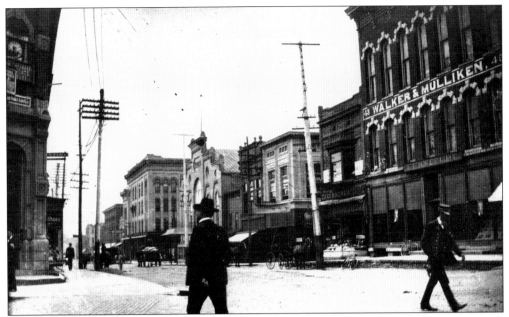

Looking south on Neil Street from the corner of Main Street, sometime prior to 1907, carriages are parked along the sidewalk and a wagon makes its way down the middle of the brick thoroughfare as pedestrians go about their business for the day. Within a few years automobiles will come to dominate the streets of Champaign.

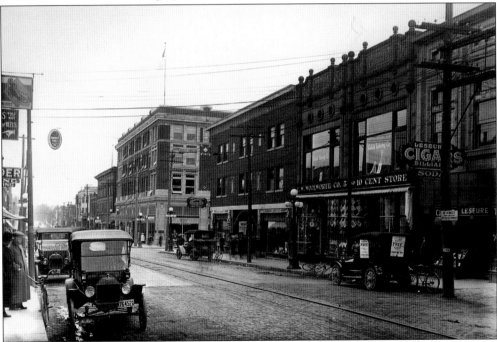

Looking south from the corner of Main Street in 1916, as photographed by B. A. Strauch, Neil Street has a vintage look with automobiles now parked on either side. Along the brick street Lewis and Company Department store may be seen in the distance. Woolworth's 5 and 10 Cent Store and a cigar store are visible on the near right.

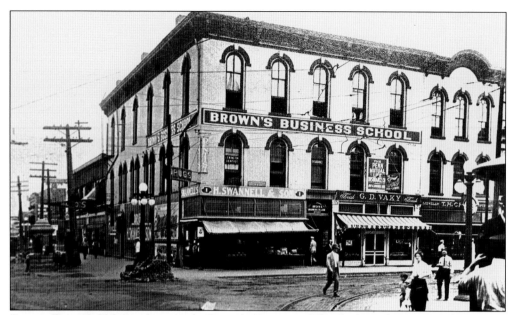

Swannell's and Vaky's, along with Brown's Business School, figured prominently in this photograph taken on July 7, 1914, on the corner of Main and Neil Streets. The fountain visible in the lower left was moved to Scott Park until 1993, when it was finally returned to its original location.

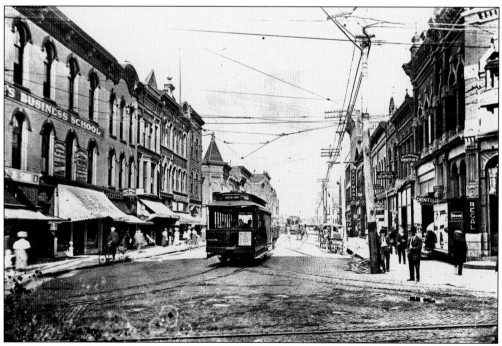

Here is another look at downtown from a slightly different vantage point. As a streetcar makes its way along the brick thoroughfare, pedestrians mill about the sidewalk. A portion of Brown's Business School may be seen at the near right of this image, and overhead the street is crisscrossed with electric lines.

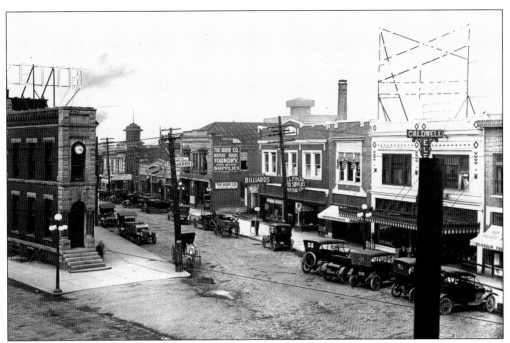

Taken around 1916, this photograph by B. A. Strauch offers a view of Hickory Street from a high vantage point. The flatiron building, which once housed the *News-Gazette*, is visible to the right as automobiles are parked in front of a billiard shop and other stores along the street. These buildings have since been razed to make way for a parking lot.

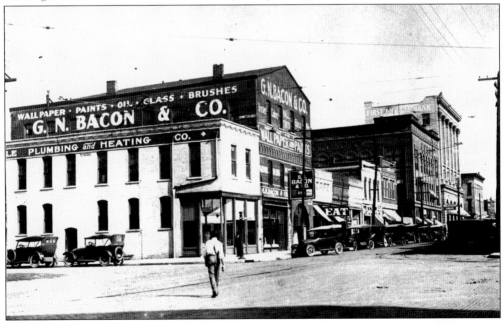

Over the years, Walnut Street also became a key street in the renaissance of downtown Champaign. At the time this photograph was made in the 1920s, a heating company and paint store occupied this corner with a restaurant and other small stores lining the street up to the First National Bank building in the distance.

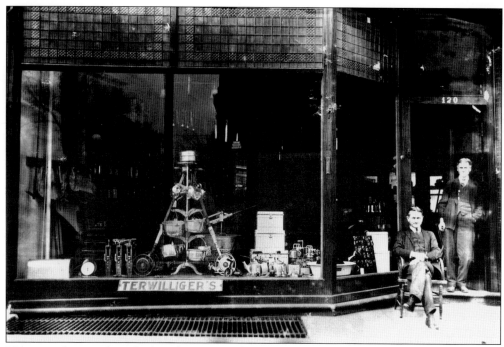

Many retail stores flourished in downtown Champaign in the early years of the 20th century. Here the owner and a trusted employee posed in front of Terwilliger's hardware store in 1908 or 1909. The enterprise was located on Neil Street across from the city hall building.

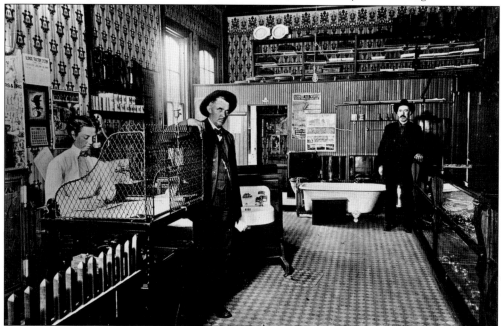

Many other goods and services were also offered in the city. This photograph provides a rare glimpse inside a plumbing store in the early 1900s. A state-of-the-art sink, bathtub, and other fixtures available for sale are displayed in the store with professional-looking employees posed for this photograph.

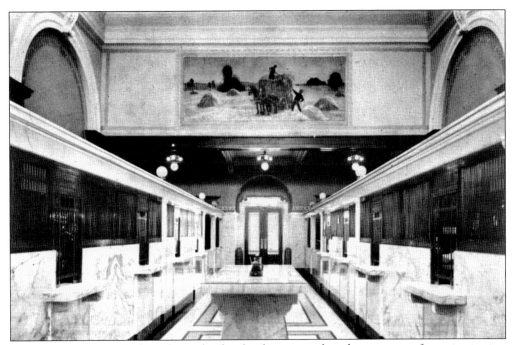

The Cattle Bank might have been the first bank in town, but the most significant institution in the early growth of the city was probably the Trevett-Mattis Bank, founded in 1861. This illustration shows the main banking room looking toward the entrance of this ornately finished building.

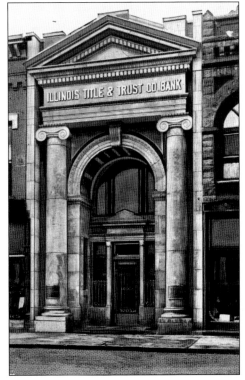

Other early banks were the Citizens State Bank, which was established in the 1890s and incorporated in 1908; the Commercial Bank; and the Illinois Title and Trust Company, which was incorporated in 1902. Located at 10 Main Street, the Illinois Title and Trust Company became the Illinois Trust and Savings Bank of Champaign.

Founded in 1882 by Edward Bailey, William S. Maxwell, and James C. Miller, the Champaign National Bank was located on the corner of Main and Fremont Streets. The bank building was constructed in an Italianate design with Corinthian pillars and a red sandstone facade. The building was damaged in a fire in 1987 and demolished in 1990.

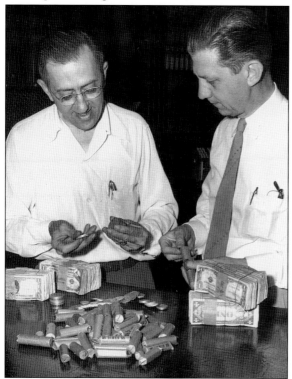

In this photograph from 1953, Lyle Blue (left), long-term treasurer of the Champaign National Bank, and Phil Hundley (right) look over stacks of paper money and rolls of coins at one of the most successful and respected financial institutions in downtown Champaign.

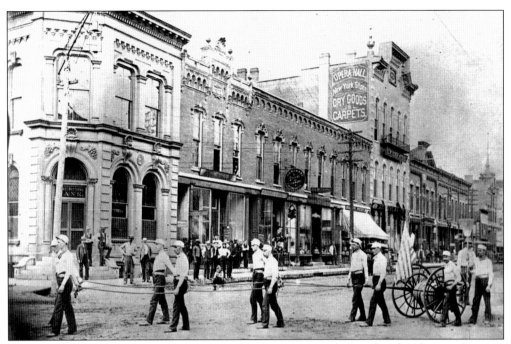

In this vintage photograph of about 1895, looking west on the south side of Main Street, a parade of local firemen is making its way down the street. Trevett Hardware was then located at 28 and 29 Main Street, and the First National Bank, one of the most prominent financial institutions in town, was situated on the corner of Main and Walnut Streets.

Completed in 1910, the First National Bank became the first building in Champaign to feature steel reinforced masonry. Both the interior and exterior are designed in a lavish Beaux-Arts style. Upon completion, the bank became one of the most prominent buildings rising into the sky in downtown Champaign. In recent years, a national banking chain acquired the local institution.

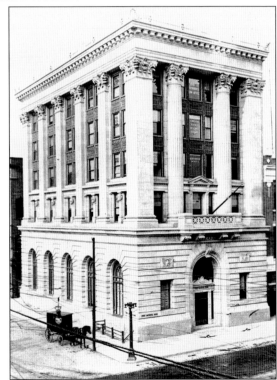

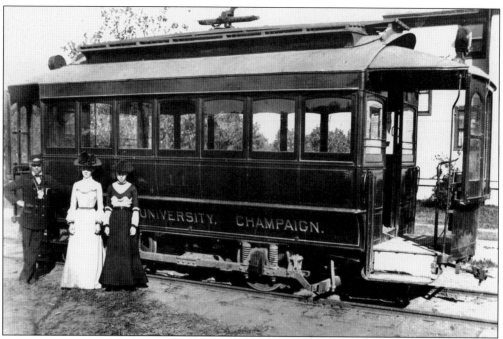

Much of the charm of Champaign in the early 1900s may be attributed to the operation of streetcars, which rattled through town. In their heyday, the vehicles served nearly all of the twin cities, including the University of Illinois campus, as evidenced by this classic streetcar with "University" emblazoned on its side.

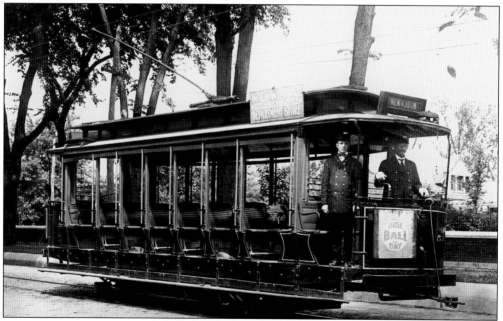

A number of streetcar models served the city of Champaign over the nearly 50 years that the system operated in the community, including this open-air vehicle on which the conductors stand ready to assist passengers. On a hot summer day, riding in one of these cars became a good way to cool off.

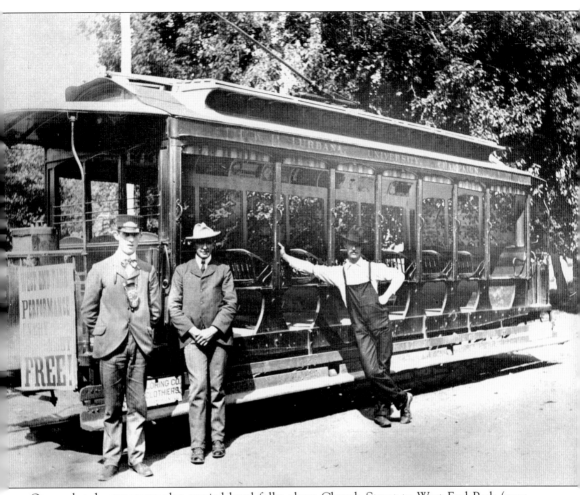

On weekends, streetcars also carried local folks along Church Street to West End Park (now Eisner Park), which was situated at what was then the western edge of Champaign, almost to Mattis Avenue. This amusement park included carnival rides, refreshment booths, and a theater. Streetcars also carried fans to local baseball games.

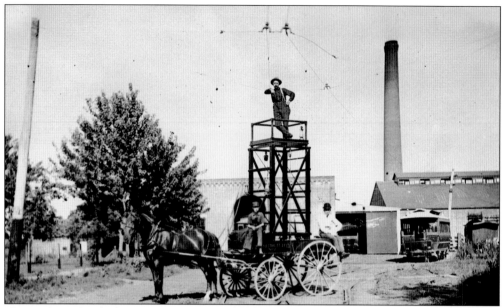

Electric lines for the streetcars had to be serviced periodically by horse-drawn repair wagons outfitted with a tall scaffold. Here workers demonstrate how they could climb the scaffolding and readily work on the lines. Luckily, the man hanging onto this 600-volt wire is standing on a wooden platform.

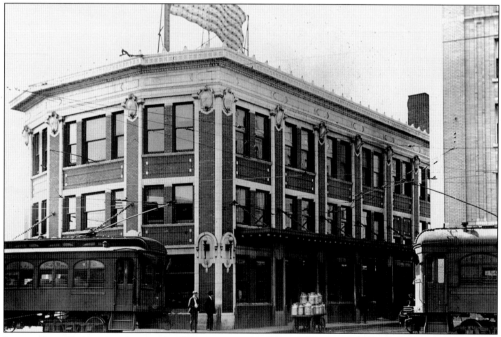

Located on University Avenue in Champaign, the Illinois Traction System Office Building and interurban station served as headquarters for both the streetcar and interurban operations under the leadership of William B. McKinley. For many years, streetcar fares were just 5¢. In the 1920s, fares jumped up to a dime, where they remained until the company went out of business in 1936.

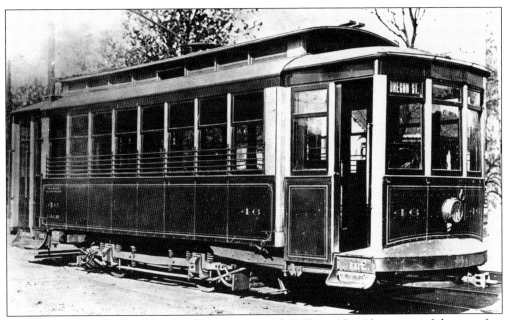

Manufactured by the Danville Car Company around 1907, car No. 46 was one of the very first steel-sided streetcars on the Champaign-Urbana line. The many rows of rivets needed to hold these stalwart vehicles together prompted a local newspaper to refer to them as "battleship cars."

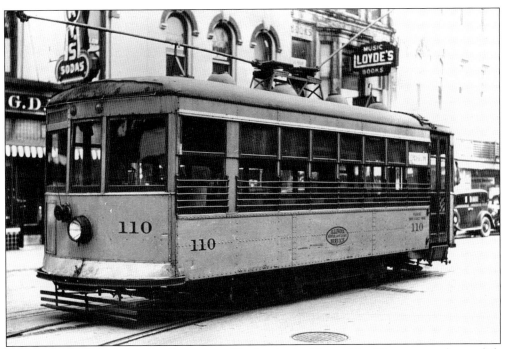

Made by the Ambassador Car Company of St. Louis, the Birney No. 10 was not only a stylish model, but also the last streetcar to operate on the Champaign-Urbana trolley line. Designed late in the second decade of the 20th century by Charles Birney, this streetcar was photographed on Main Street, looking northeast.

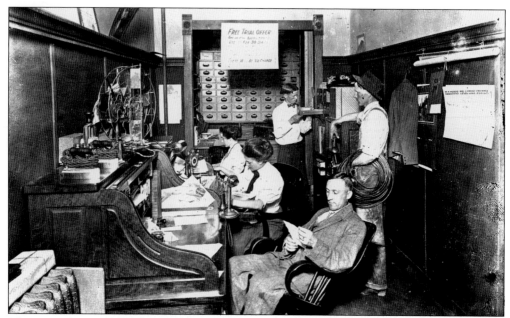

The interurban and other services operated from the Illinois Traction Company on University Avenue. Among the modern conveniences and technological wonders in the offices of the company were two telephones on the desk. Two devices were necessary to reach everyone in town, because at the time, two telephone companies operated in Champaign.

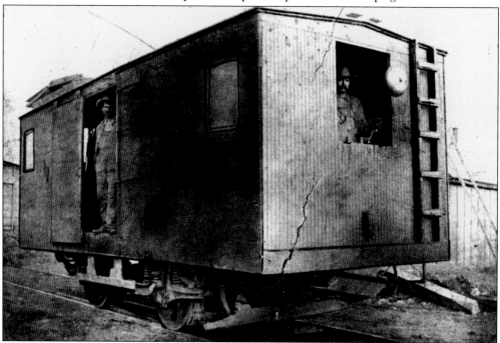

Called the "Lost Boy," this car, which "looks for all the world like a packing box on wheels," according to a local newspaper article, was used to haul freight and as a utility vehicle. It was later put into service as a line car between Danville and the twin cities. Made about 1900, this photograph shows Robert Spearman (left) and an unidentified motorman.

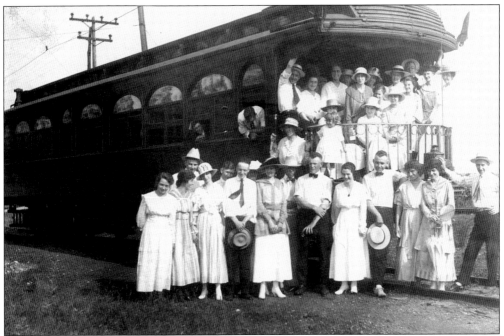

In 1903, an extension of railway service, known as the interurban, was completed between Champaign and Danville, with stops along the way. Folks in St. Joseph were "greatly delighted over the prospect of being brought into closer touch with the outside world." Here a group of passengers, most likely on a Sunday outing, gathered on the tracks for a group portrait.

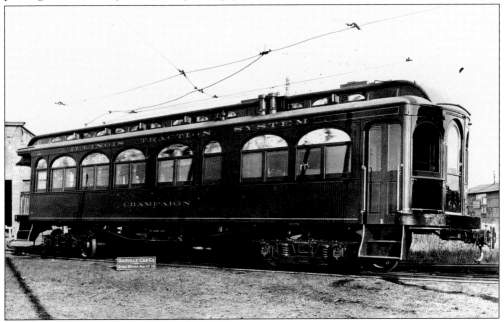

Built for Sen. William B. McKinley, founder and president of the Illinois Traction System, Illinois Traction Office car *Champaign* went into service in March 1910 and was used as a private car until after World War I. It was then used as a sleeper car in the route between Champaign and St. Louis, Missouri, and saw later service on other routes.

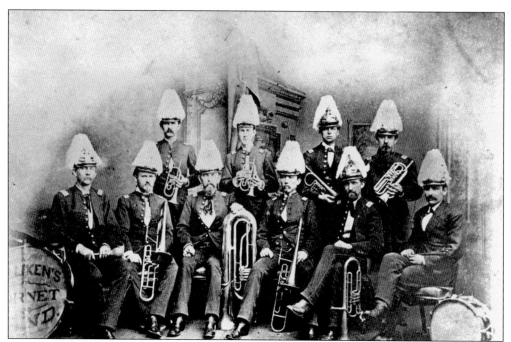

Amusements were often held at West Side Park, including concerts. Mulliken's Cornet Band entertained local folks there and elsewhere in the community in the 1870s. This early photograph from 1873 shows the members in full regalia with their instruments. Not long afterward, the band quit playing in 1876.

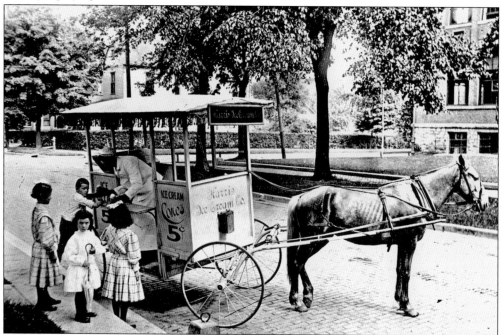

Along with a bustling downtown, Champaign folks have enjoyed their homes along tree-lined brick streets. In this photograph, four children gather around an early ice-cream wagon pulled by a weary horse at Hill and Randolph Streets, near the old high school and West Side Park.

Laid out as a public square in 1854, West Side Park became the first city park in Champaign County in 1859. From the bandstand adorned with flags, Theodore Roosevelt addressed the people of Champaign in 1912, as the presidential candidate of the Bull Moose Party. On that eventful day, as evidenced in the other photograph, thousands of people crowded into the park to listen to the former president speak in favor of his candidacy.

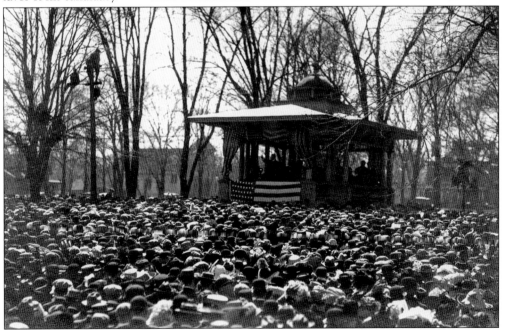

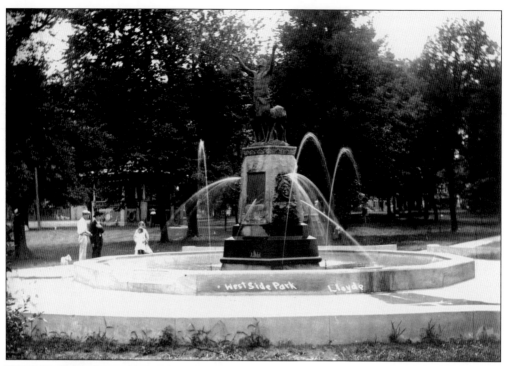

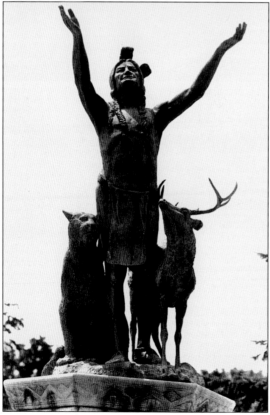

Known as *Prayer for Rain*, this bronze fountain, including the statue of a Native American warrior flanked by a deer and mountain lion, became a local landmark. On August 13, 1944, the *Courier* newspaper reported, "Prompted, perhaps, by this summer's stubborn drought, the Champaign park board has announced plans for renovation of the statue, 'Prayer for Rain,' which has stood in West Side Park for 55 years. The statuary was executed by Edward Kemey, also sculptor of the Chicago Art Institute lions."

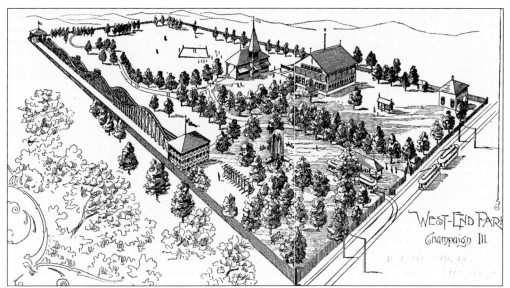

Down the streetcar line on Church Street was West End Park (now Eisner Park), which featured amusements, including a shooting gallery, a ride similar to a roller coaster, and a summer theater accommodating up to 600 people. This illustration depicts the entertainments available at the park, which was then on the outskirts of Champaign. Beginning in 1894, exciting Fourth of July celebrations, including picnics and fireworks, were held in the park.

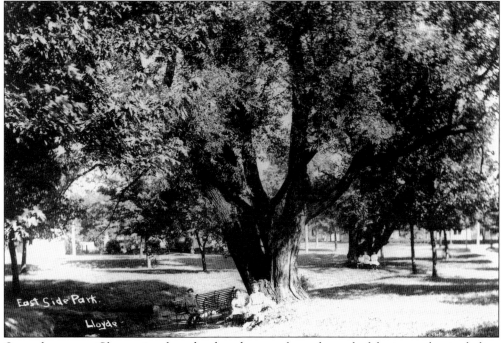

Over the years, Champaign has developed a number of wonderful city parks, including mini-parks and sports facilities. East Side Park (now Scott Park), another of the earliest green spaces in town, has always been quite charming, as shown in this early-20th-century photograph of children seated under a shade tree. This park is located just north of the University of Illinois campus.

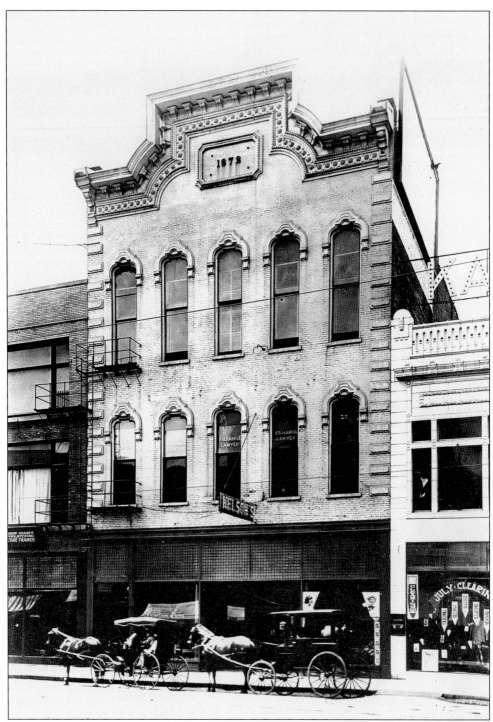

The Eichberg Opera House was located at 22 Main Street in a building erected in 1872. Max Eichberg and Ben Baer operated a dry goods store on the first floor. The ticket office was situated on the second floor, and the opera house occupied the third floor. The Eichberg Opera House flourished for more than two decades, but closed its doors around 1895.

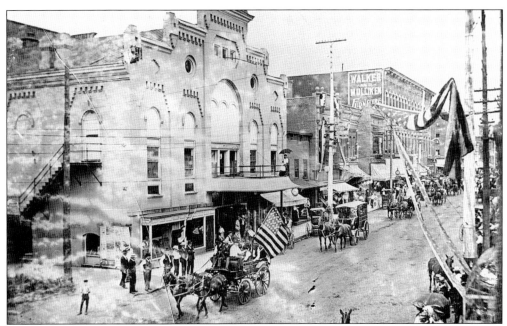

Around the dawn of the 20th century, the Walker Opera House opened its doors in a building on Neil Street and quickly became one of the most popular hot spots in town. Entertainments ranged from high school plays to vaudeville acts on national tour. Playbills recommended, "Physicians and railroad men are requested to leave their seat number, as this will enable ushers to find them if called for, without disturbing the audience." The notices further advised, "If you are not occupying the seat your coupon calls for, do not get offended if you are asked to change." Patrons were further advised not to leave their tickets in their other clothes at home, not to loiter in the lobby, not to stare at the women coming out, and not to be reluctant to laugh at anything that is really funny. In 1913, when the Walker house was destroyed by fire, people were already being lured away from vaudeville acts to moving pictures and nickelodeons.

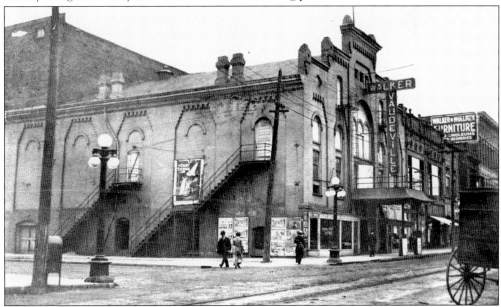

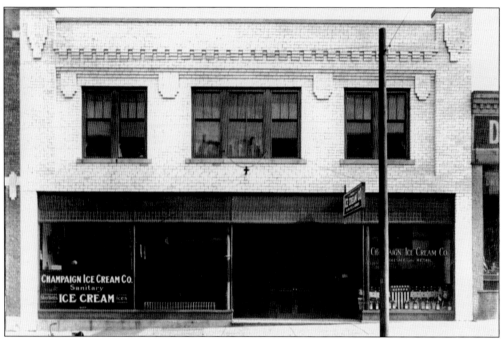

Located here at 115 East University Avenue in 1913, the Champaign Ice Cream Company satisfied the sweet tooth of local folks for many years. In 1928, Beatrice Creamery Company bought the enterprise and it became known as the Meadow Gold Ice Cream Company. Delos L. Huxtable continued as manager of the enterprise.

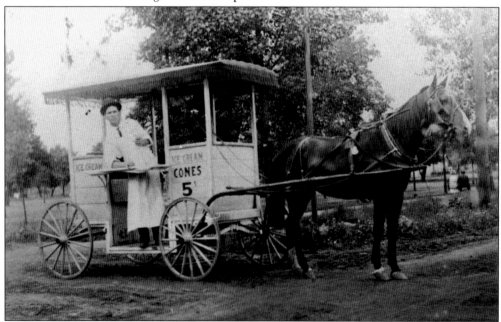

Taken in the 1920s, this photograph shows the delivery services of the Champaign Ice Cream Company, which operated an open, horse-drawn wagon. Rambling up and down brick streets, this unidentified ice-cream man offered up cones, priced at 5¢, to young and old alike on hot summer days.

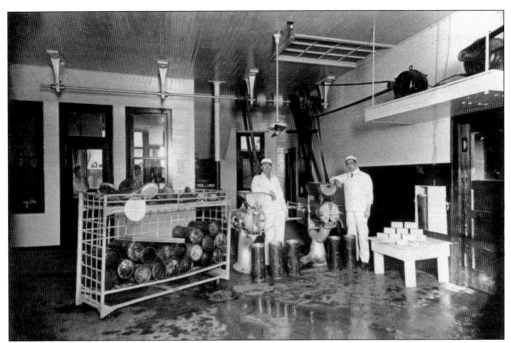

This photograph from the 1920s offers an interesting peek inside the production operation of the Champaign Ice Cream Company. The workers, who were making another batch of tasty ice cream, take a break from their labors for this memorable image of themselves and their equipment.

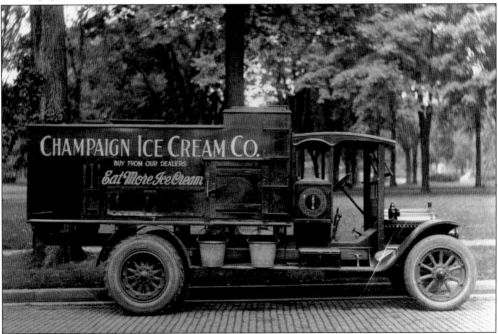

Ready to make its deliveries for the day, this now-vintage truck of the Champaign Ice Cream Company encourages people to "Eat More Ice Cream," which is brazenly advertised as "The Health Food." The truck was parked along a brick street, most likely next to West Side Park.

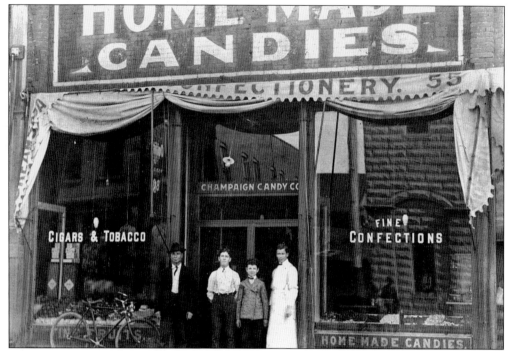

When George Demetrios Vaky arrived in Champaign in 1899, he founded the Champaign Candy Company. As a boy, he had learned the art of candy making in the candy factories of Boston and the Boston Confectioner's School, which he attended from 1884 to 1886. In this early photograph, Vaky (right) posed with Peter Vriner (left), who founded a popular rival confectionery.

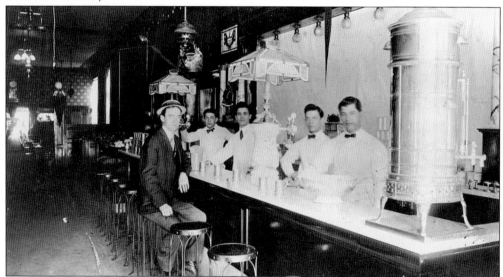

Located at 3 Main Street, Vaky's became one of the landmark businesses in downtown Champaign. Originally called the Frat Confectionery, the enterprise frequently served University of Illinois students. This photograph from 1899 shows the interior of the shop with employees behind the counter and 28-year-old founder and owner George Vaky in the right foreground. The seated customer is John White.

The memorabilia depicted here includes an order form for ice cream from the establishment, which was then still known as the Frat Confectionery. Also displayed are a box of Vaky's Victoria chocolates along with a photograph of the founder and owner on the street next to his delivery truck.

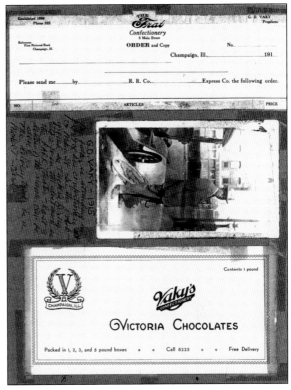

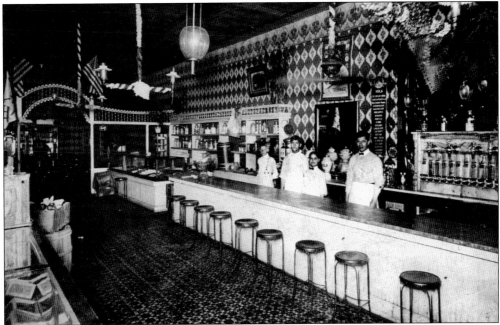

When the sweet shop remodeled in 1923, its name was changed to Vaky's Confectionery. In this photograph, showing off the new interior, George Vaky is standing behind the counter at the right. The local institution remained a popular hot spot known as Vaky's Confectionery until George Vaky died on January 31, 1944.

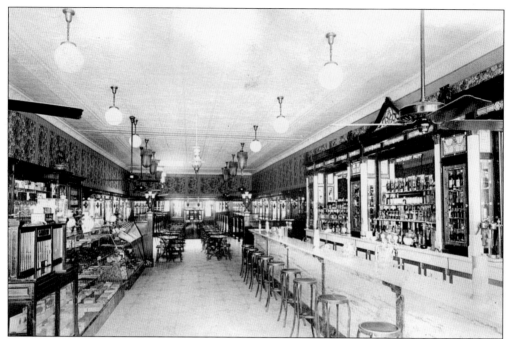

Along with Vaky's, Vriner's became a very popular hot spot in downtown Champaign. Located on Main Street, for many years the establishment remained the only vintage soda fountain in Champaign and one of the last in the nation. Taken between 1918 and 1920, this photograph offers a glimpse of the early interior of the shop.

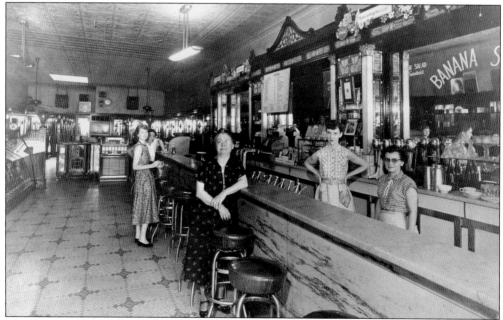

Over the decades, the interior of Vriner's largely remained the same. In this photograph from 1955, the styles of dress of both patrons and employees may have changed over the years, but the decor of the soda fountain, including tin ceiling, does not look much different from when it was founded early in the century.

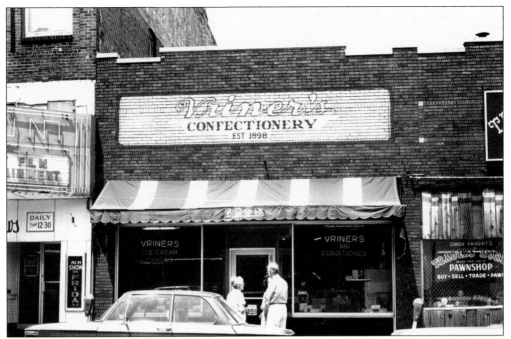

Sandwiched between a pawnshop and a local theater, Vriner's became a local landmark over the years. Conveniently located along Main Street, between the train station and the heart of downtown Champaign, the soda fountain remained popular with young and old alike for most of the 20th century.

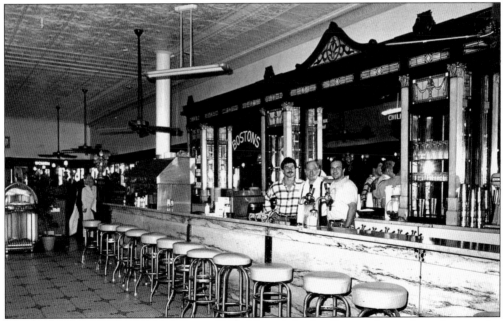

When this photograph was taken in 1985, Vriner's had still not changed much over the course of the years. Its traditional atmosphere became the source of the soda fountain's charm and commercial success as one of the best-known and enduring businesses in downtown Champaign.

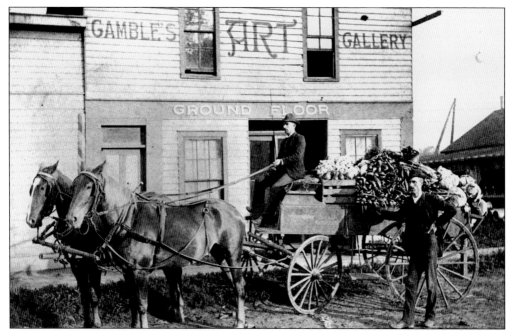

Over the years, transportation in Champaign gradually shifted from horse-driven vehicles to the automobiles. With Gamble's Art Gallery as a backdrop, Louis Mittendorf is sitting in a wagon, with Ed Hoyt standing at the side in this photograph made around 1888–1889. The Mittendorfs had a farm on Bloomington Road between State and Randolph Streets.

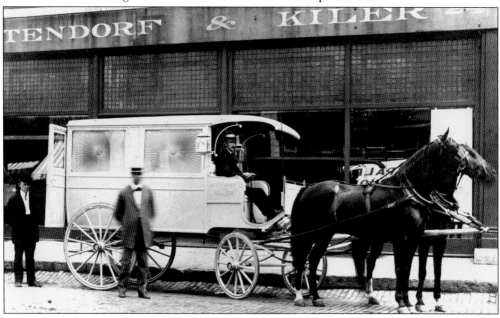

In the early 20th century, people still relied on horses in death as well as in life. Established in 1889, Mittendorf and Kiler served as a combination funeral parlor and furniture store. In this photograph of their hearse taken around 1910, the three men, from left to right, are Fred Moller, Louis Mittendorf, and Jasper Richardson in the driver's seat. Automobiles would soon replace horse-drawn wagons.

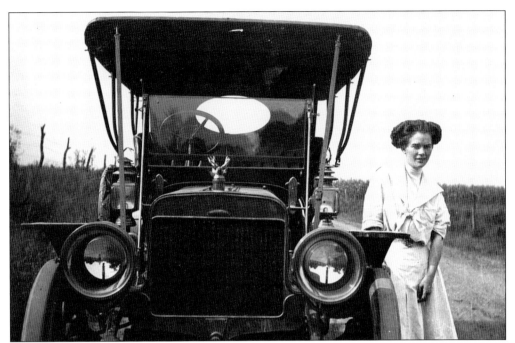

With the arrival of the automobile in the early years of the 20th century, folks could not only putt-putt around town, but also ramble out into the country for a Sunday drive. Standing next to her vehicle in the early 1900s, this unidentified young woman poses for the camera in the open farm fields that surround the city of Champaign.

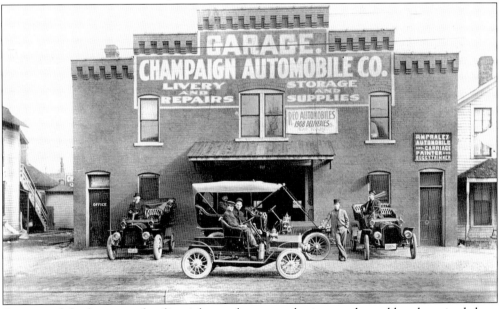

As automobiles became a familiar sight on the streets, businesses that sold and serviced them replaced harness shops and liveries. In this carefully composed photograph, the owners of the Champaign Automobile Company are showing off their enterprise at 504 North Neil Street and several of their shiny new cars. Note that the business still maintained a livery, along with the garage, and that red vehicles would soon become available.

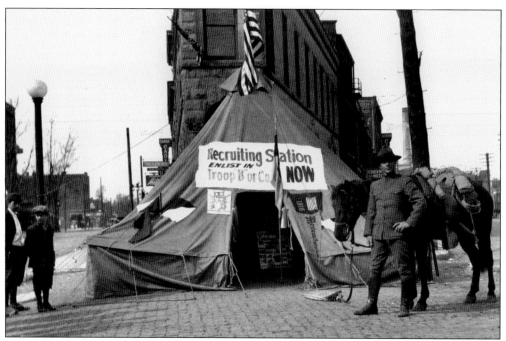

World War I wrought many changes in the community. For the first time in American history, men and women were drawn overseas to fight on foreign soil. The conflict reached into the very heart of downtown Champaign, as evidenced by this recruiting tent set up in front of the flatiron building at the height of the war effort.

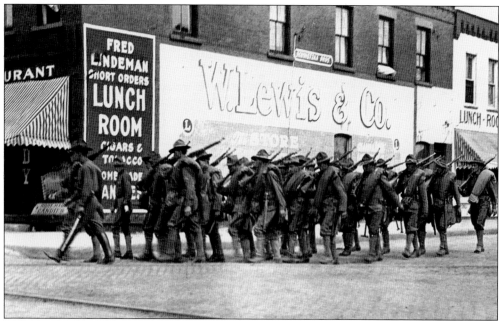

This photograph and the image at the top of the facing page document two different views of a long row of recently recruited doughboys marching through downtown Champaign. In this photograph, they are striding past a lunchroom and a sign for the W. Lewis store on their way to the train station, which was just down the block and around the corner.

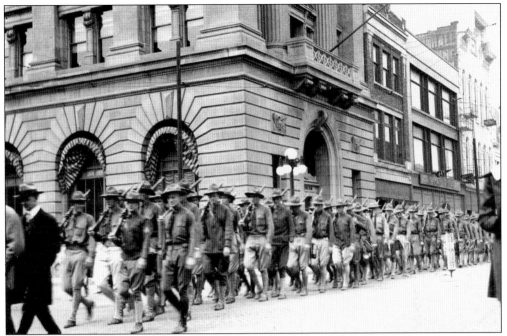

These soldiers continued their march past the First National Bank building on Main Street and on to the Champaign railroad station facing Chester Street, where they climbed aboard a waiting train to be shipped to camp. After basic training, they were sent to stateside assignments or across the Atlantic Ocean to the battlefields of Europe.

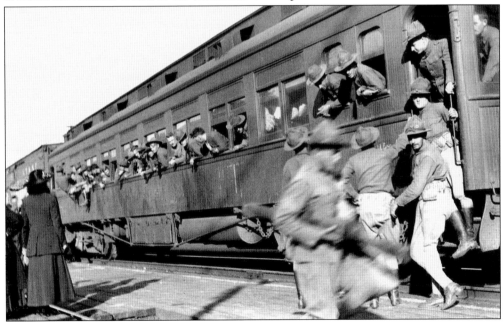

The last of the soldiers, identified as Troop D Cavalry, clamored aboard a waiting train at the station onto passenger cars already crowded with their comrades-in-arms. Many soldiers leaned out windows to wave goodbye to loved ones. Many of these young soldiers never returned to their homes in Champaign.

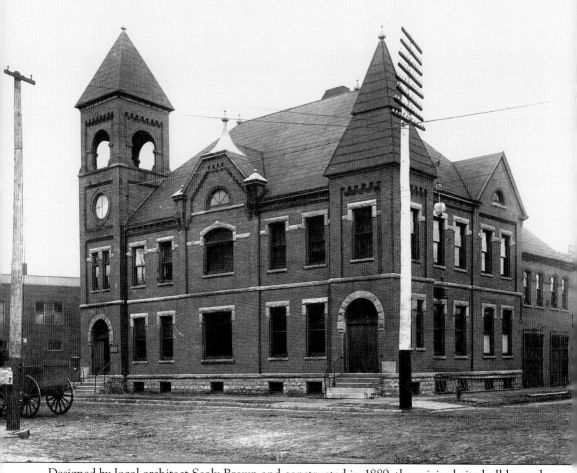

Designed by local architect Sealy Brown and constructed in 1889, the original city hall housed all city services, including police, fire, and library. When constructed, the building committee reported, "All materials used in the construction and fixtures were the best of their kind; all labor was honestly performed." The committee promised "that very soon the building be thrown open for general inspection by the citizens, that they may see for themselves for what their money has been used." Even the *Champaign County Gazette* became enamored with the building, especially the council room: "The large and elegant room was lighted brilliantly, and the rich furniture showed off to excellent advantage. The Aldermen lounged lazily in their tilting armchairs, which they enjoyed so much that they seemed unwilling to adjourn." Despite early enthusiasm, the new city building did not hold up well, probably because of the low ground on which it had been erected. Within 45 years, the firehouse floor had buckled and the building had acquired a rundown appearance. The *News-Gazette* declared, "Too long have we put up with a building that is a disgrace to the community."

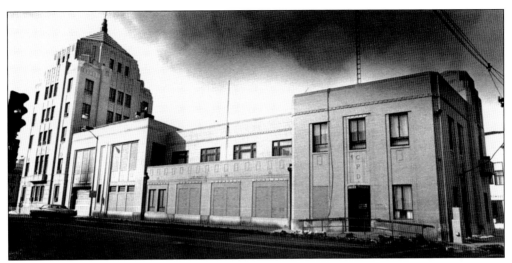

By a margin of four to one, voters supported bond issues for a new city building and an expansion of Burnham City Hospital. City leaders envisioned a "monolithic concrete structure" similar to the Los Angeles City Hall. This new building would house all city services, except for the public library, which had already moved into Burnham Athenaeum. Despite the constructor's struggles with "quick sand" and cave-ins triggered by heavy rain and vibrations from passing streetcars, the building was completed in October 1937. As seen in these two views, other than interior remodeling the present city building has withstood the test of time.

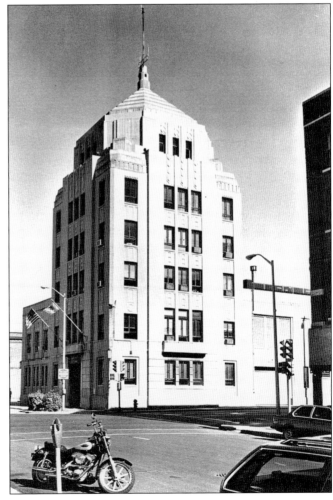

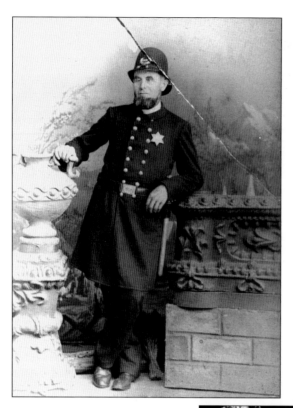

In 1858, a single lawman, Marshall E. McClam, protected West Urbana on horseback and on foot. Two years later, city leaders officially established a police department and a month later approved funding for building a calaboose. In this studio portrait, John Frederick Melahn, who served on the police force in the 1890s, posed in full uniform, including helmet, badge, and nightstick.

By the early 1900s, the police department had grown from 1 to 10 able-bodied men like this group of officers in 1918. Over the years the department relied on advances in technology, largely transportation and communication. For many years, red lights on the Champaign City Building were used to call officers. Upon seeing the lights, the officers rushed back to the station for word about a crime or other emergency.

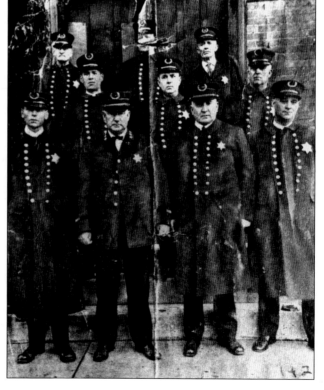

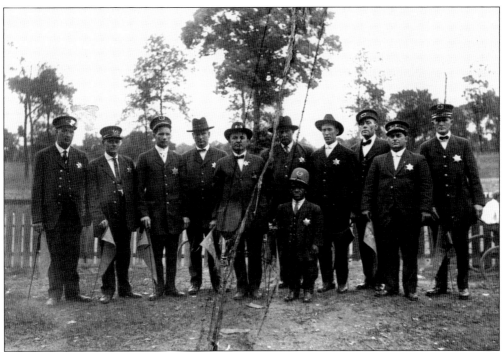

These two photographs show the changing faces of the Champaign Police Department—in 1914 and 1934. In both instances, the officers are smartly dressed. However, over the years, the department had undergone many changes as well. Champaign police officers first made their rounds on horseback and later on bicycles and motorcycles, along with automobiles. Regular beat officers and post telephones were gradually phased out in the 1960s. Officers now rely on an array of high-tech equipment, notably computers in squad cars and offices.

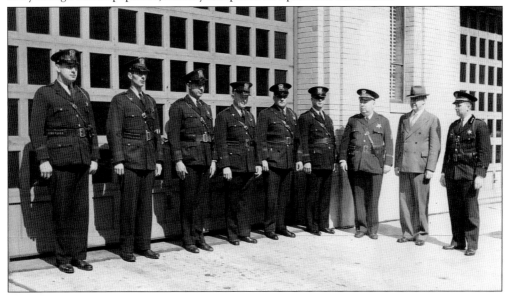

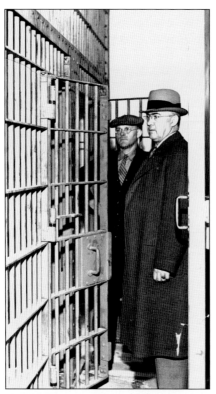

"Lawbreakers in Champaign will find brand new cells awaiting them after the city moves into its new building, now nearing completion," according to a local newspaper article in 1937. Here Mayor James D. Flynn inspects some of those new cells in which local police needed to secure local miscreants.

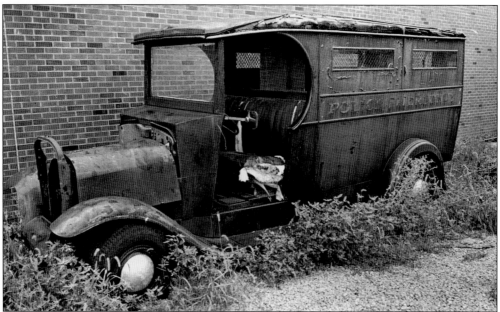

One of the most notable police vehicles was a Buick touring car equipped with one-way communication. Another noted automobile was this Studebaker paddy wagon, which was purchased in the late 1920s. From that time through the 1950s, the wagon was used to transport prisoners to the city jail seen in the photograph above. Long abandoned and nearly forgotten, the old paddy wagon has since been restored.

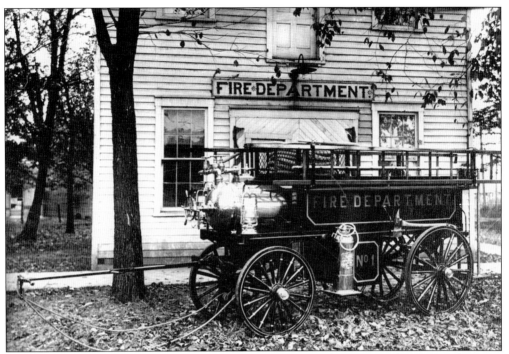

"Our town is built mostly of pine and would be very easily burnt up. Why doesn't the town council make a move to get up a fire company, a hook and ladder, and a bucket company?" a writer urged in a local newspaper article in 1861. Not much was done, however, until May 15, 1865, when the city council officially organized the fire company with certificates for each member. Here are two early fire wagons, which served the community for many years before the fire department moved into its modern headquarters on Randolph Street.

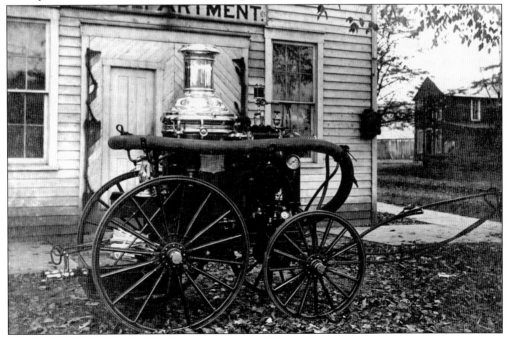

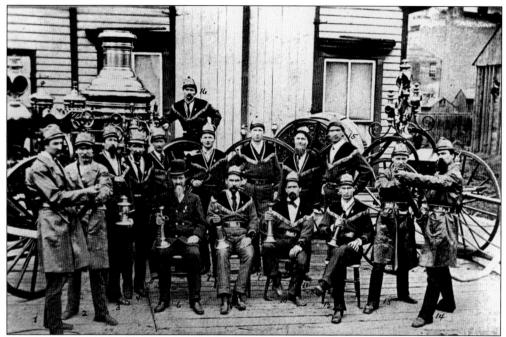

At the ring of the fire bell, the members of the department jumped into action. Only the fastest runners were allowed to join the fire company. Thomas Naughton of Abernathy's Studio of Champaign made this group portrait of the smartly dressed members of the Bell Engine and Hose Company No. 1 of the Champaign Fire Department in February 1880.

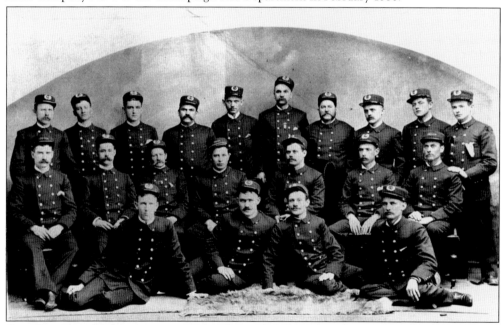

Over the years, the fire service not only advanced in many broad areas of technology, but also in styles of dress. Taken around 1900, this group portrait shows the members of the Champaign Fire Department sporting the latest fashions of the day and ready to meet the most challenging fires that might beset the city.

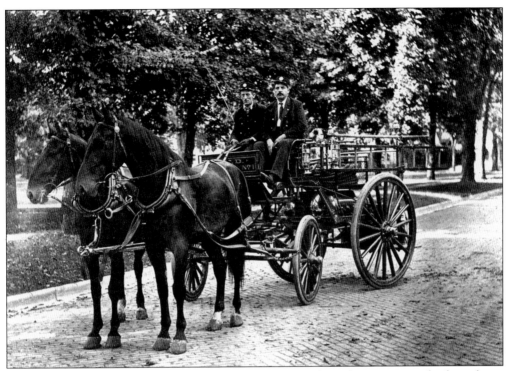

As shown in these photographs of two firefighters perched on their wagon and a lone driver posing with reins in hand, from the founding of the Champaign Fire Department through the early 20th century, the service relied upon horsepower to battle blazes. Teams of swift, sturdy horses speedily transported firefighters and their array of equipment to the scenes of fires throughout the city.

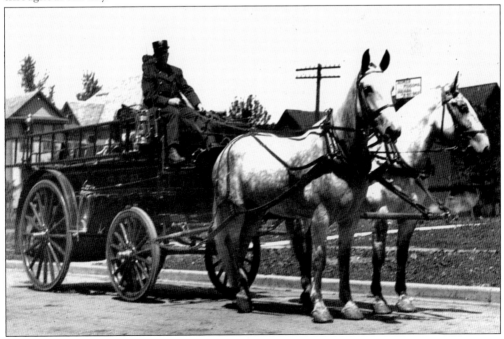

Over time, the Champaign Fire Department turned to vehicles powered by the internal combustion engine. By 1915, the department had even acquired an automobile. In these two photographs, each taken from a slightly different perspective, the fire chief proudly poses next to the stylish, yet useful vehicle. The photographs were taken along Chester Street, looking north.

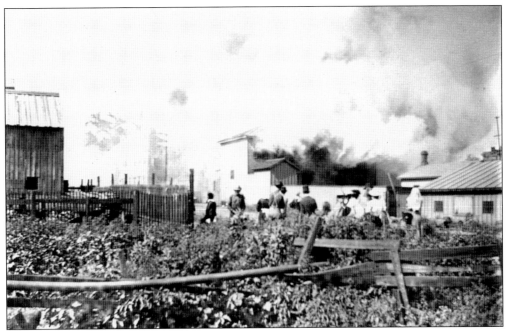

Over the years, a number of fires reshaped the landscape of downtown Champaign. One of the most dramatic fires occurred on July 12, 1898, when flames consumed the Doane House. Standing on the street, the people in this crowd appeared justifiably horrified as the stately old building next to the railroad track burned to the ground.

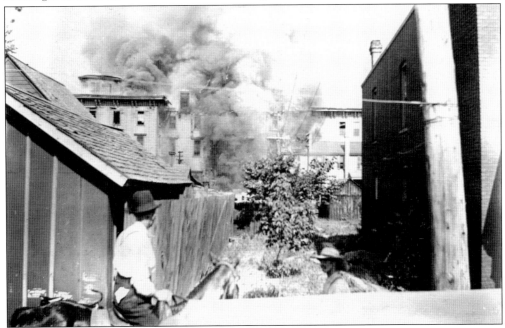

Shocked people rushed to the scene of the fire, but like this man on horseback, they could only gaze at the rising smoke from a safe distance. Even members of the Champaign Fire Department could only look on helplessly as flames quickly destroyed the local landmark that had served the community for so many years.

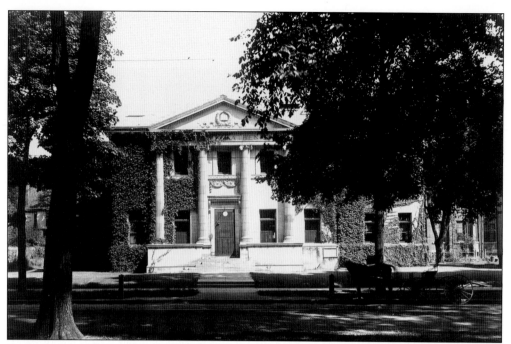

"It is a lamentable fact that we have as yet no public library," observed the *Champaign County Gazette* on October 26, 1859. It would be another nine years before people formed the Champaign Library Association and not until 1894 that the library moved into the Burnham Athenaeum, facing West Side Park. In this *c.* 1900 photograph, a horse and buggy are parked along the shady street.

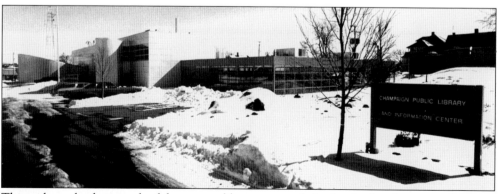

This wide-angle photograph of the present library was made in the depths of winter in February 1978, just after the library had moved into its new quarters on Randolph Street. However, the building soon proved to be inadequate and the library is currently planning to construct new facilities nearby.

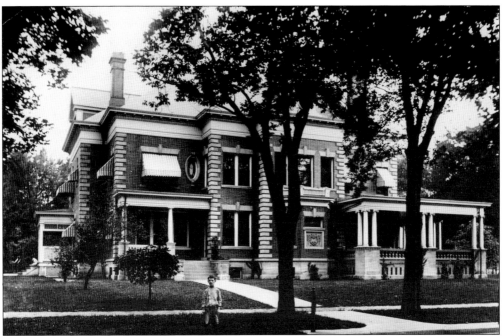

Over the years many fine homes came to be built in Champaign—the Wilber Mansion, B. F. Harris Home, Mattis Home, McKinley Stipes Home, Salon House, and William B. McKinley Home—along with the Trevett Home and Newton Harris Home pictured here. Constructed in 1900 by J. R. Trevett on Elm Street near West Side Park, this home has 18 rooms. Designed in a Georgian Revival tradition with leaded stained-glass windows, its walls are 17 inches thick. Another of the more lavish homes in town is the Newton Harris Home on West Church Street. In the *c.* 1900 photograph below, the family gathers in the spacious yard surrounded by an iron rail fence.

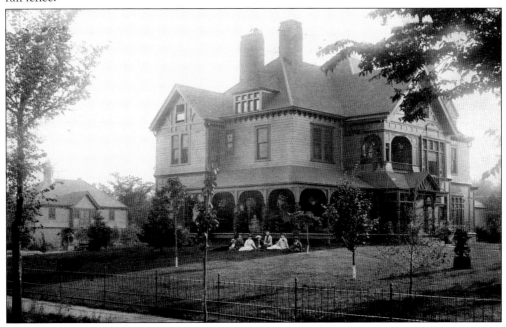

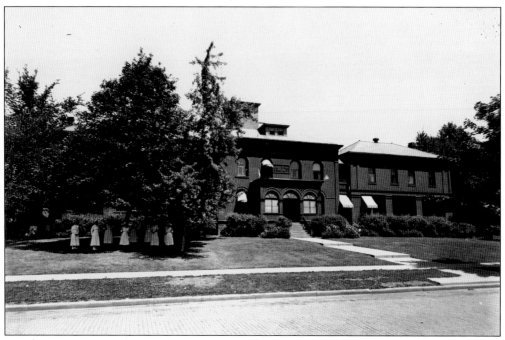

Burnham City Hospital opened its doors on March 6, 1895, and admitted the first patient four days later. With a capacity of 25 beds, the hospital treated 136 patients during its first year. Over the years the hospital underwent several expansions. Taken about 1920, this photograph captures the restful atmosphere of the city hospital with several nurses clustered in the shade.

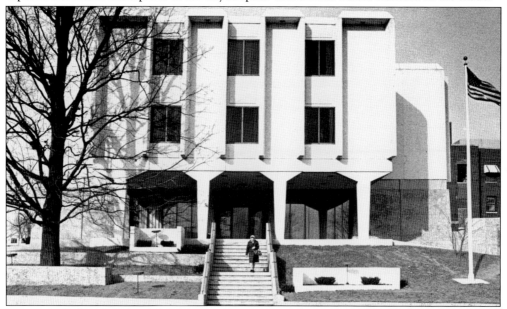

Between 1966 and 1968, the city constructed a large modern expansion of Burnham City Hospital. The hospital subsequently merged with Mercy Hospital (now Covenant) and was later closed altogether. In 1993, the building was sold to the State of Illinois Natural History Survey for offices and laboratories but has since been torn down to make way for apartments and retail stores.

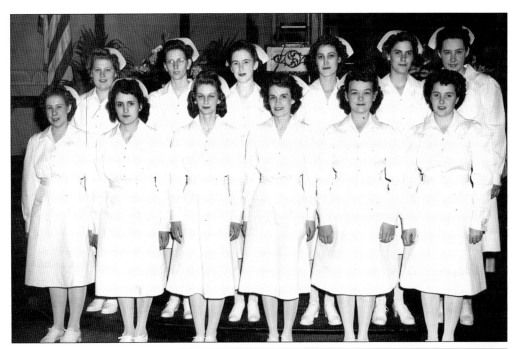

The Julia F. Burnham School of Nursing was first organized in 1904. Over the years, the school trained many classes of nurses, who were desperately needed in local hospitals and elsewhere. One photograph depicts the nursing class of 1943, which graduated in the midst of World War II. The other photograph from the same time period shows a group of nurses learning to prepare special dietary meals for patients at the local hospital.

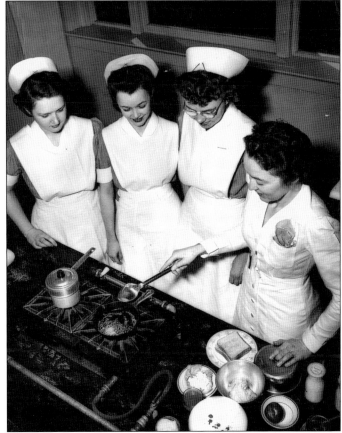

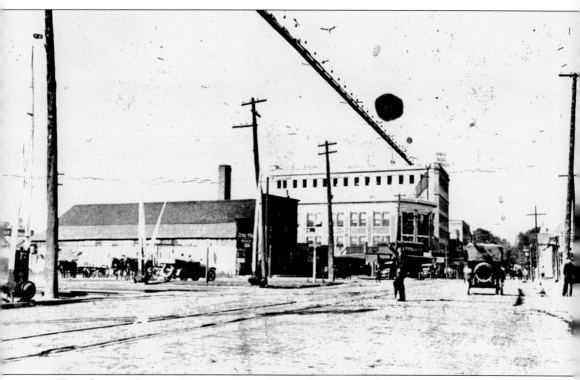

This photograph was taken sometime after the beginning of the 20th century, prior to 1923 when the underpass was constructed. It offers an unusual view of University Avenue, looking west, with the Illinois Traction Building in the distance and the level railroad tracks in the foreground. It is hard to tell if the man crossing the street is waving farewell to the past or offering a greeting to the bright future that lies ahead for Champaign.

Four

A BUSTLING CITY
1920 TO PRESENT

People in Champaign entered the Roaring Twenties with a sense of optimism, especially as the university continued to attract large numbers of people—not only students, but also football fans and other visitors.

Champaign had become a bustling city, as described in the *Champaign Souvenir Edition*, a promotional booklet published in 1924: "A great deal of pride is taken in the large business district of Champaign. In order to be more commodious, the streets have been widened. These are beautified by boulevard lights that extend to the city's limits."

Model Ts and other automobiles now rolled down the streets, replacing horses, except for the occasional milk wagon. People not only shopped downtown, but also enjoyed movies at the Orpheum and Virginia Theatres, which replaced vaudeville shows in the opera houses.

The *Champaign Souvenir Edition* further noted, "The city is under the Commission Form of City Government which has been very successful in administration. A very efficient police force and fire department are maintained to protect the welfare of the citizens. Under the Park Commission, control of six city parks are established which not only beautify the city but are so situated to serve everyone. The administration has been very active in bringing about the construction of new viaducts, the new depot, and two more miles of paved streets in the city, bringing the total up to fifty miles over paved streets within the corporate limits."

The souvenir edition concluded, "When our history is viewed in the light of the interest vested here, our past growth is not surprising. The remarkable advantages and attractive opportunities centered here reach out and draw people to us. The things done in the past, prosperity of the present, and the plans for the future, speak well of a great Champaign."

Unfortunately, the Great Depression brought economic hardships for the American people. Champaign was somewhat cushioned from the full effects by the university. Yet many students could no longer afford a college education. Enrollments dropped off, and everyone endured hardships of some sort.

Champaign took advantage of Public Works Administration (PWA) funds to construct a new city building and to expand Burnham City Hospital. People survived the 1930s only to have the decade lead to another world war. Like others in the nation, local people sacrificed greatly in this war, but at its conclusion, they were rewarded with decades of prosperity.

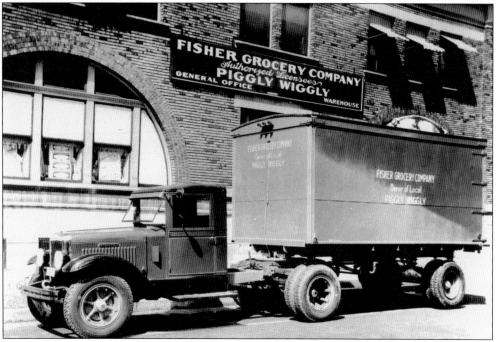

Founded in 1916 in Memphis, Tennessee, by Clarence Saunders, Piggly Wiggly became the first self-service grocery. At its peak, the chain had 2,660 stores, including many in Champaign. Parked in front of a local Piggly Wiggly warehouse, this vehicle was the first semitruck to deliver groceries to stores throughout the region. It was put into service in 1933. Below, these later model delivery trucks for the Eisner Grocery Company were used locally. Both vehicles were parked next to the meat cooler at the old warehouse at 202 Market Street in August 1957.

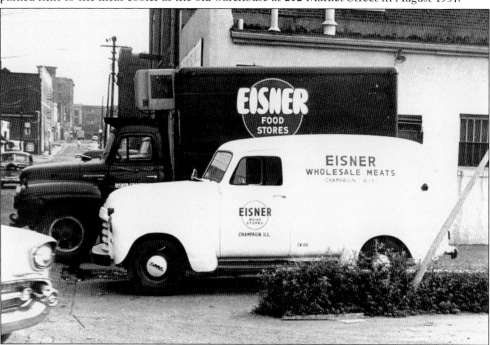

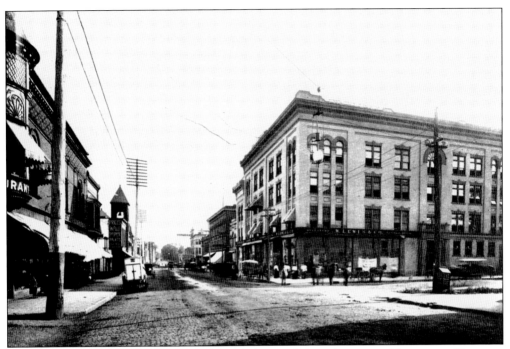

Lewis Department Store was once a wonderful place to shop in downtown Champaign. However, a tragic fire completely destroyed the building in 1915. Owned and operated by Wolf Lewis, the store was soon rebuilt and resumed its place as one of the most visible and popular retail businesses on Neil Street. These before and after photographs show the enterprise in its original building and just after the store reopened in 1916.

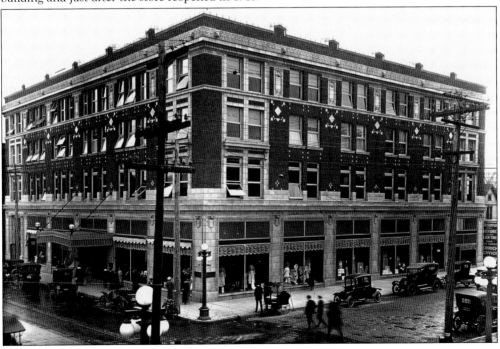

When Robeson's first opened in 1874, it was known as "the Farmer's Store." In this early photograph, three women display their Easter hats at a time when Robeson's was still considered a store for area farmers. Over the years, however, the local enterprise grew into a major department store, as evidenced in this interior photograph of the hat department in the early 20th century.

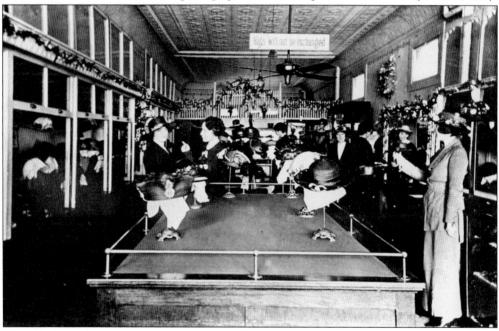

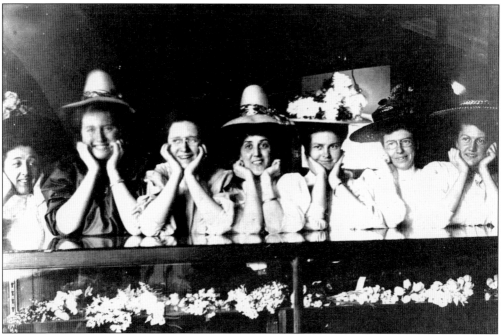

Hats remained perennial favorites for downtown shoppers. This group of ladies modeled the latest styles, although the location may have been at Robeson's or Mulliken's Hat Shop. Whatever the case, the merchandise was irresistible, as evidenced in this photograph of the interior of the shop.

Robeson's became one of the largest and most distinctive independently owned department stores in the United States. In this 1968 photograph, the store brightens the corner of Church and Randolph Streets. In 1970, Frank and Kyle Robeson oversaw the groundbreaking for a Howard Johnson's next to their enterprise when Robeson's was the major anchor store in Champaign. However, Robeson's finally closed on February 17, 1990.

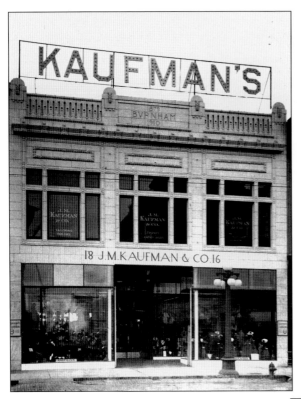

Downtown Champaign was once the place to shop in east-central Illinois, and department stores, including Kaufman's, brought a special grandeur to the city. All the other major retailers, except Kuhn's, have since succumbed to shopping malls, which now fringe the city. However, Kaufman's was once a "must" on any shopping expedition. The stately facade and window displays, ranging from salt dot ties to elegant clothes, enticed shoppers to amble inside for a closer look.

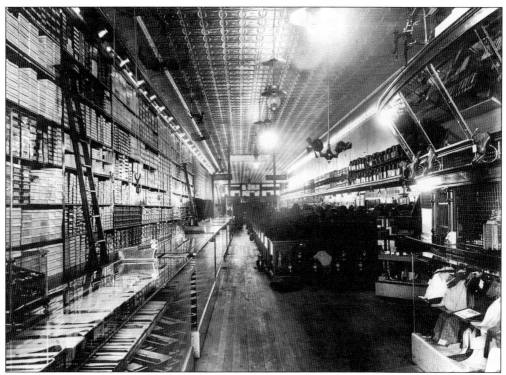

Shopping for convenience and price, people have now abandoned the unique flavor of downtown Champaign for the uniformity of chain stores in malls, which are no different from any other city in the United States. However, the interior of Kaufman's once featured a breathtaking assortment of merchandise, ranging from men's suits to women's dresses.

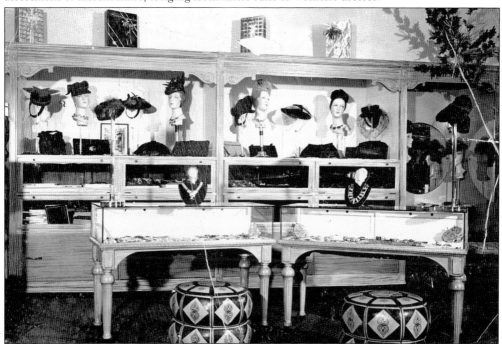

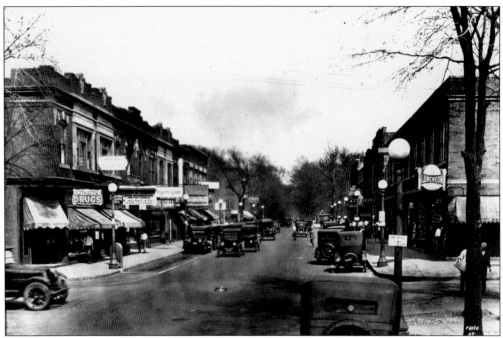

University of Illinois students, faculty, and staff patronized stores and shops in downtown Champaign, but over time a thriving Campustown grew up along Green Street. At one time, the aptly named street was lined with lush trees and lawns, but an assortment of stores had sprung up by the 1920s. In these two views from the early 1930s, looking east and west, automobiles have come to dominate the thoroughfare, which is already crowded with drugstores, restaurants, and other commercial enterprises.

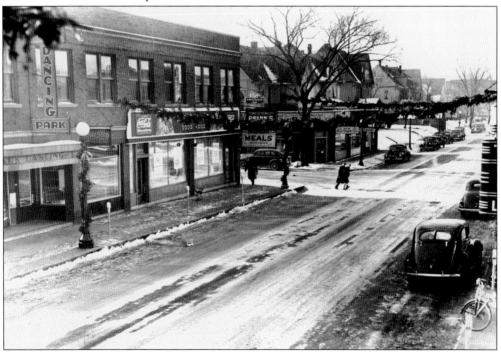

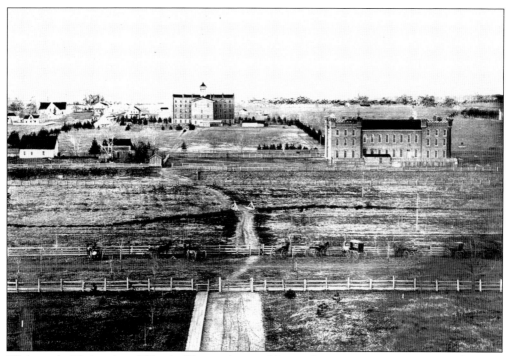

Without the University of Illinois, Champaign would never have grown into a commercial center. In this bird's-eye view of the early campus, with Old Main Hall in the distance and Green Street in the foreground, the university had plenty of room to grow over the years. Curiously, most of the growth of the campus occurred in Urbana, and for many years the only major building in Champaign was the armory, located on the corner of Armory and Sixth Streets. However, over time, students, faculty, and staff did most of their shopping in downtown Champaign or Campustown, most of which is located in Champaign.

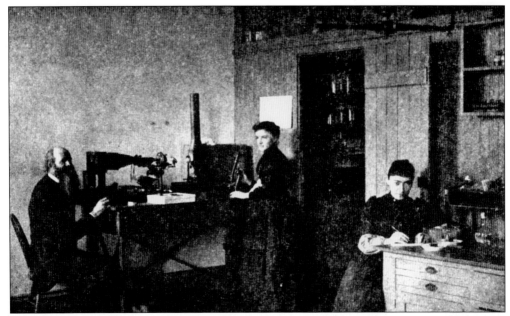

The University of Illinois not only brought economic prosperity to the city of Champaign, but also prestige to the community because of its academic excellence. This early photograph shows Prof. Thomas J. Burrill and two students in his botanical laboratory. Burrill's lab was the first in the nation to offer instruction in microscopic organisms.

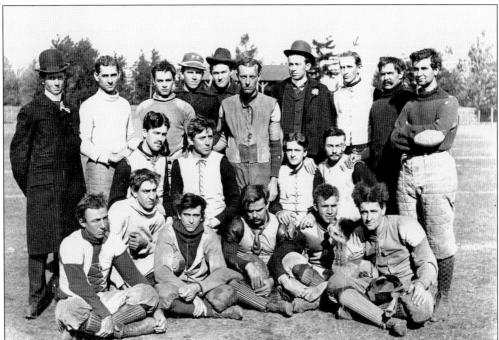

Students at the university studied hard, but also enjoyed recreation, such as a popular new game known as football. The popularity of the sport would lead to the construction of Memorial Stadium in 1923, followed by the heroics of Red Grange, the "Galloping Ghost." In the meantime, students such as this group of guys photographed in 1897 enjoyed intramural football.

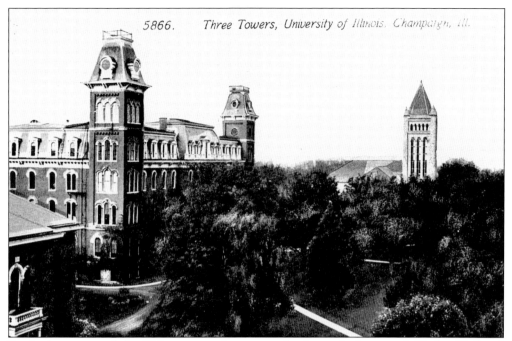

By the beginning of the 20th century, the campus landscape had matured. Harker Hall and Altgeld Hall had taken their places on either side of University Hall, which was also known as the "Twin Towers." The Illini Union would later replace University Hall, but the University of Illinois had already become one of the premiere universities in the nation.

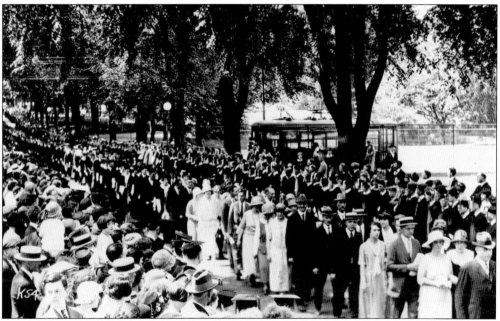

The university, originally known as the Illinois Industrial University, opened in 1868 with 77 students, 13 professors, and 4 assistants. Over the years, the university has steadily grown and each year graduates several thousand students. In this photograph from the early 1900s, graduates and proud parents throng the sidewalks with a streetcar in the background.

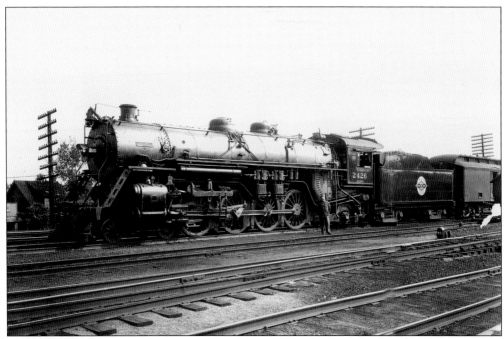

Since the railroad tracks were first laid in Champaign, then known informally as West Urbana, steam locomotives regularly chugged up to the depot. Burning wood and then coal, these powerful engines, such as this locomotive from the 1920s, pulled both freight and passenger cars until replaced by diesel locomotives, such as the Panama Limited Streamlined below. When this diesel locomotive pulled into the train station in 1942, officials touted it as the "most modern streamliner built in this country." This train provided service between Chicago and New Orleans, cutting the travel time from 18 to 15 hours.

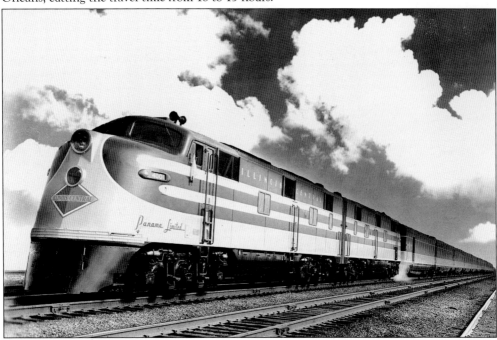

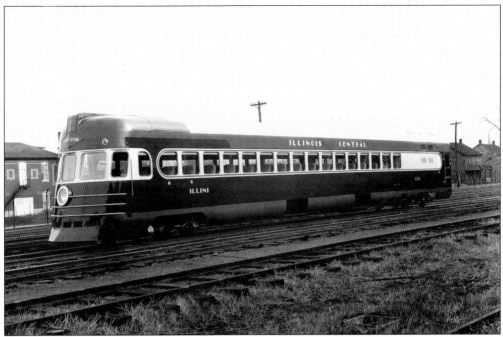

The passenger route between Chicago and New Orleans included stops in Champaign and other cities along the way. However, for many years the Illinois Central Railroad also provided service between Champaign and Union Station in Chicago. Students, faculty, and staff at the University of Illinois, along with businessmen and others in the community, often took advantage of this special service. Generations of University of Illinois students from the Chicago area in particular relied on the Illini train to transport them to campus and back home again. These two photographs depict an Illini train, including a glimpse inside a passenger car.

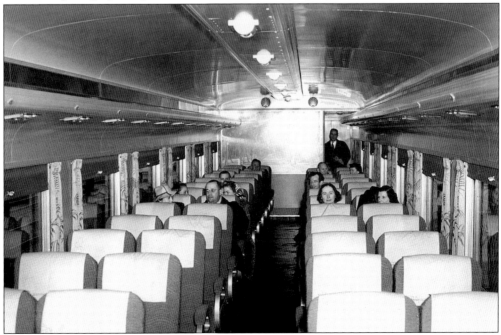

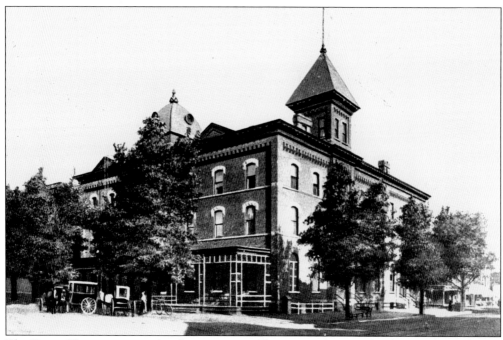

The Doane House was once the place to stay in Champaign, but travelers became tired of train whistles and clanging bells—even before the stately hotel burned in 1898. They sought a quieter locale at the Hotel Beardsley, which was constructed on Neil Street, just north of Main Street. The Hotel Beardsley later became Tilden Hall, one of the best hotels in town, along with the Hamilton and Inman hotels. However, with the closing of Tilden Hall in 1965 and the Inman around 1975, there is no longer a single hotel in downtown Champaign. Here are two views of the Hotel Beardsley in its heyday.

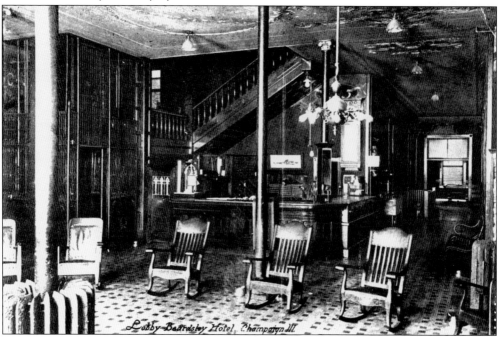

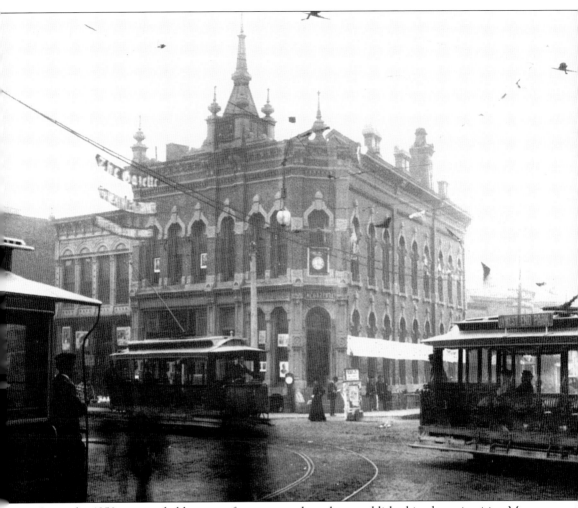

Since the 1850s a remarkable array of newspapers have been published in the twin cities. Most enterprises were short-lived, but the *News-Gazette* can trace its history from the *Urbana Union*, the first newspaper in the county, which began publication in 1852. The original *News-Gazette* building was this elegant edifice on the corner of Main and Neil Streets, with the city hall tower in the distant right.

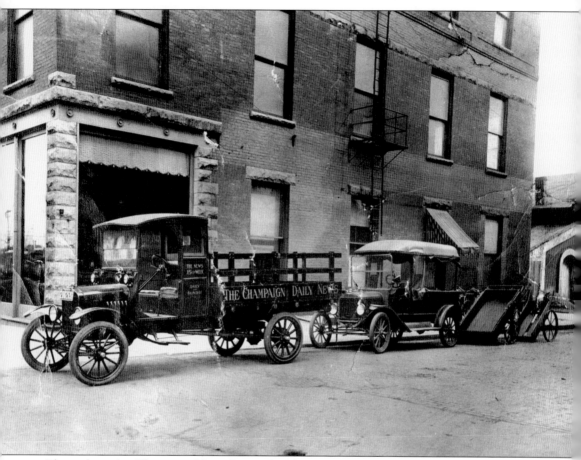

This is how the *Champaign News-Gazette* building appeared in 1919, with trucks standing at the ready for delivery of that day's newspaper. Only one floor of the building in the background was used for newspaper operations, and the stable at the right was torn down in 1938. As an independently owned enterprise, the *News-Gazette* continues to prosper as a local institution with offices in an impressive building on Main Street.

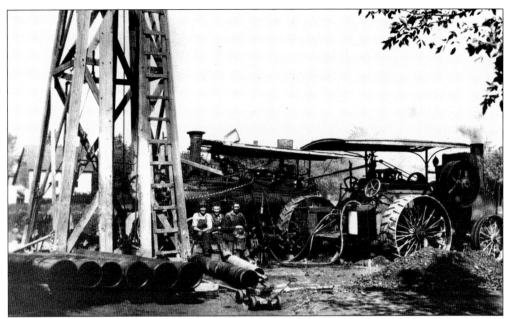

Water service began in Champaign when a group of men looking for coal deposits sunk shaft and struck water. So, on February 27, 1884, the Union Water Supply Corporation was formed. The water company has proved to be one of the most reliable municipal services in the twin cities. Early wells were drilled with steam-powered equipment, as shown in this image from the late 1800s.

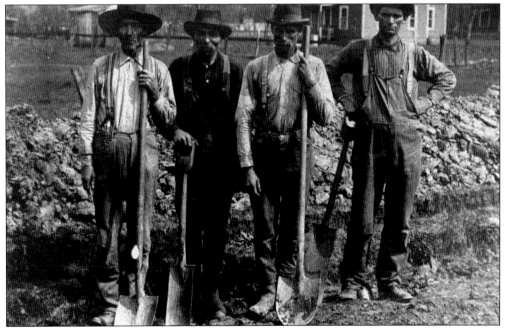

Much of the work for the water company was once done by hand. Posing with their shovels, these laborers dug many of the trenches for water lines that now network the city. People often take water for granted, but without a ready supply, the growth of Champaign, Urbana, and the University of Illinois would never have been possible.

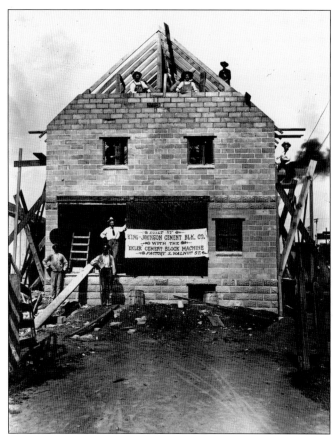

Champaign may have grown because of the railroad and the University of Illinois, but several manufacturers have also prospered in town. One of the earliest enterprises was the King-Johnson Cement Block Company, which supplied what they called "artificial rock." Over the years, Bonner Tool Factory, Collegiate Cap and Gown, Universal Bleacher, and Kraft-Humko also emerged as major companies. In these two photographs of King-Johnson, workers paused in their labors to show off both their products and the results of their construction skills.

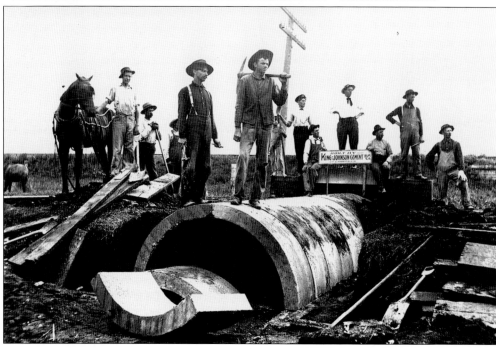

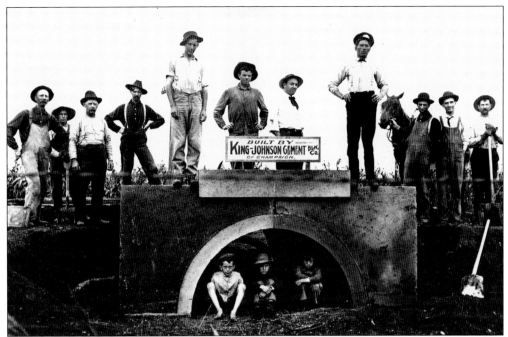

Here company workers proudly stand over a new viaduct while three children crouch beneath the arch. King-Johnson cement blocks were often used in the construction of viaducts and drains, which were especially important in Champaign, where city streets once routinely flooded. As a local historian wrote, "That portion of Champaign now occupied by business blocks was a slough and the mud was of great depth along what is now Main Street." Taken about 1890, the photograph below shows how local folks had to often deal with the low ground and flooding.

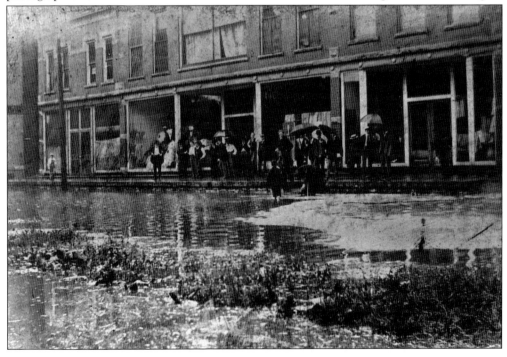

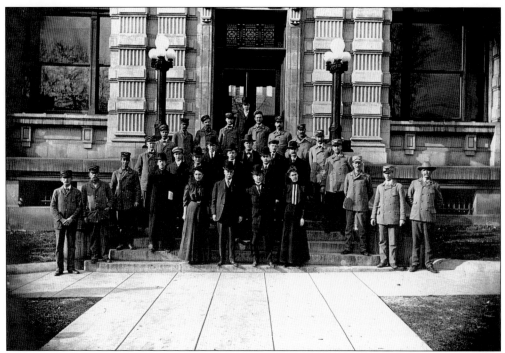

Located on the corner of Church and Randolph Streets, since its construction in 1905, the Springer Building housed the U.S. post office for many years. The stately building with its lovely interior was designed in the office of James Knox Taylor, architect of the treasurer department from 1897 to 1912. These two undated group portraits depict the many able men and women who staffed the post office in the early 20th century.

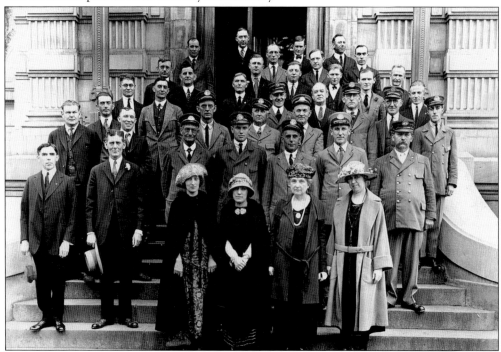

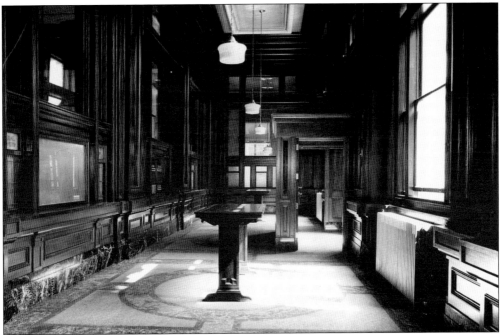

This photograph shows the lobby in the post office after it was remodeled in 1937. One really would not mind standing in line too much in such a pleasant space, especially when stamps cost just 3¢. After the post office moved into new facilities on North Neil Street, the old post office became a federal building and then Springer Recreation Center. It is now on the National Register of Historic Places.

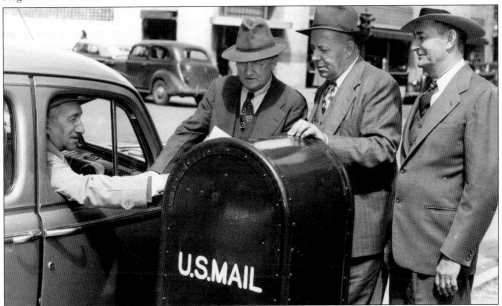

Over the years many able postal workers have served the community and occasionally added innovative new services. In this photograph made about 1945, postmaster A. C. Parres (second from left) and Hugh Wall (right), assistant postmaster, showed off a drop box, a new convenience available at the Champaign Post Office.

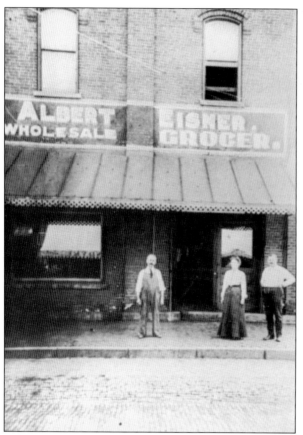

Long popular in the city of Champaign, the Piggly Wiggly chain became synonymous with the term *grocery store*. Even after the stores became Eisners, many local folks continued to affectionately refer to their neighborhood store by the more colorful name. The early photograph of the Albert Eisner grocery store shows the facade before the owner adopted the name of Piggly Wiggly. The photograph below depicts an early Eisner delivery truck and two drivers for the company.

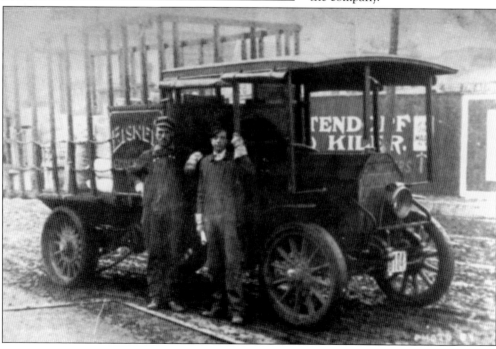

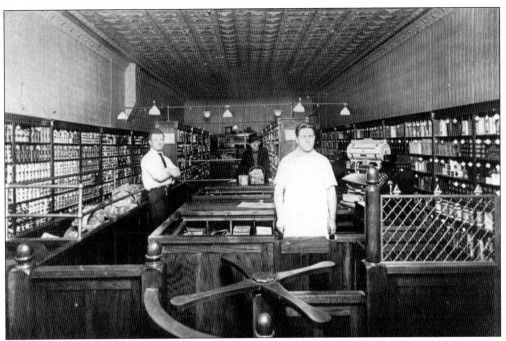

This early interior photograph of a local Piggly Wiggly grocery store portrays two employees at the ready to serve the customers of the day. Along with the tin ceiling and goods lining the walls, this store features the very first turnstile put into service by the popular regional grocery chain.

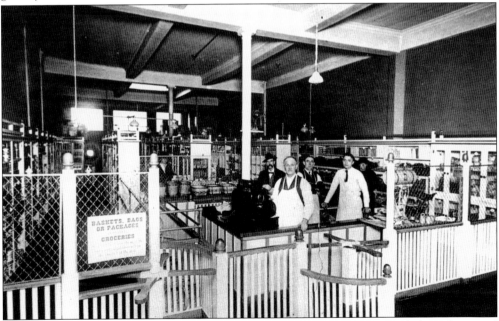

Located at 112 South Neil Street, this spiffy new Piggly Wiggly grocery includes railings and turnstiles to help direct customers through the store. Originally shoppers simply handed their list to the clerk, who fetched their groceries, but over time Piggly Wiggly adopted a new approach to grocery shopping referred to as "self-service."

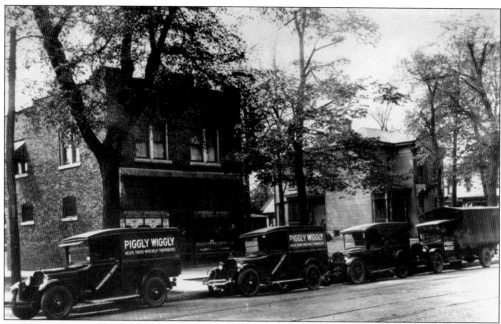

Boldly emblazoned with the slogan, "Piggly Wiggly Helps Those Who Help Themselves," which emphasized self-service at their stores, these delivery trucks lined the curb at 805 South Fourth Street in front of a neighborhood Piggly Wiggly grocery store in 1920. This was the company's first fleet of trucks.

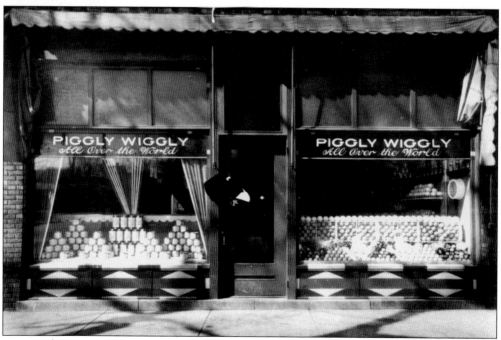

Located in the mottled shade of a quiet Champaign neighborhood at 805 South Fourth Street about 1928, the inviting front windows of this Piggly Wiggly declare the presence of the stores "All Over the World." The chain did gain wide popularity so that it did seem that there was always a grocery just around the corner.

When built in 1914, the Orpheum Theatre was meant to host vaudeville shows, but was also equipped to shoot moving pictures. Considered the most ornate theater in Central Illinois, it was designed by George W. Rapp, an 1899 graduate of the University of Illinois. The RKO chain later acquired the theater. In 1971, Kerasotes purchased and operated the Orpheum until it closed in 1983.

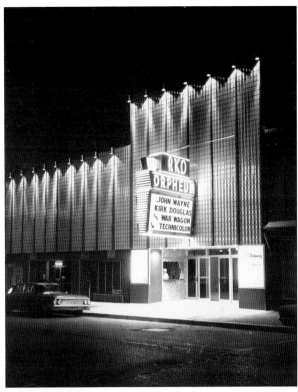

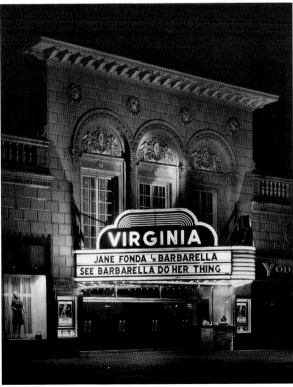

Located on West Park Street, the Virginia Theatre open on December 28, 1921. The name of the theater was chosen to avoid common names of the day. Designed by internationally renowned architects C. Howard Crane and H. Kenneth Franzheim, the theater has featured a variety of musicals, plays, and movies. In recent years, highly successful efforts have been made to preserve the Virginia.

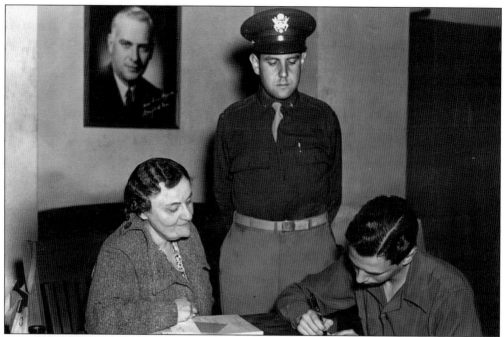

During World War II, people mobilized to support the war effort. Gene Stern, a University of Illinois student, was among the first young men in the 18-to-20-year-old group to register for selective service at the Champaign Armory. Pearl Webber registered Gene Stern while his brother Lt. A. W. Stern observed the proceedings.

Many local people made great sacrifices during the war. Here Mrs. James Campbell received a prisoner of war package representative of those given to all prisoners by the Red Cross. At the time, Mrs. Campbell's husband, a pilot from Champaign, was a prisoner of war in Germany.

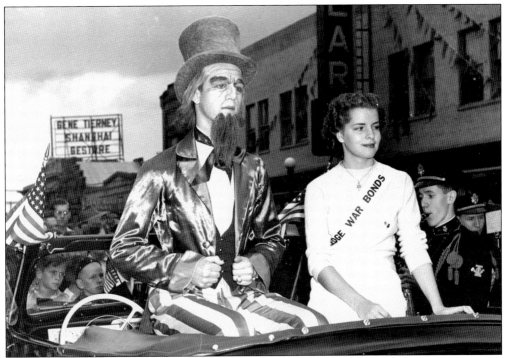

On the home front, many people worked hard to help the American cause through volunteer work, donations, and the purchase of war bonds. Nancy Nicoll, "minute girl" commander in the company of Joe Mege as Uncle Sam, encouraged people to purchase war bonds in a parade through downtown Champaign.

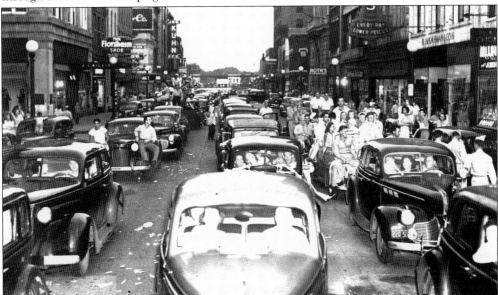

At long last, when the war ended, the men and women of Champaign who had served so courageously were able to come home once again. Downtown then became the scene of the most exuberant celebration in the city's history. Here people and automobiles jam Main Street from one curb to the other.

After West Side School, or "Big Brick," burned to the ground, the Avenue Grade School (1893–1934), as portrayed in this watercolor by Prof. Charles E. Bradbury, was built on that location. It was quietly situated among a grove of trees on University Avenue on the present site of Champaign Central High School.

Made around 1904–1905, this photograph offers a glimpse of four students hard at work reading their lessons at the Avenue Grade School with various assignments written on the blackboard. Several generations of Champaign children received an excellent education at this landmark school until it had to make way for a new high school building.

Here students at the Avenue Grade School are working out problems at the blackboard. According to Doc Shere, "The youngster never had a chance in Champaign! Almost from the beginning, the school bells began to ring, and the old admonition of 'don't be later' and 'hurry right home' could be heard five mornings a week. Summer time offered the only relief."

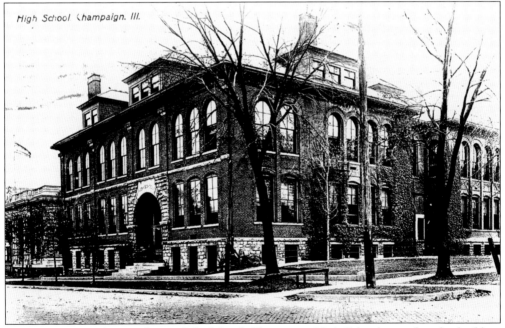

After an 1893 fire destroyed West Side School, Champaign High School moved to this building on Hill and Randolph Streets, but it became overcrowded. A building of "imposing Greek architecture" was constructed at 302 West Green Street (now Edison School). For 42 years, the high school was located there until the University Avenue building was completed in 1957.

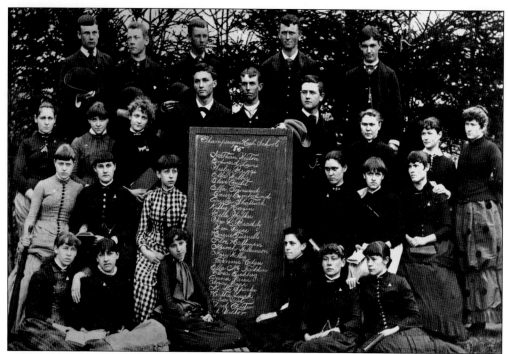

Over the years, many generations of students have attended and graduated from Champaign High School. However, the classes have grown appreciably in size from the early years when only a handful of students attended the school, as evidenced in this graduation photograph of the class of 1885.

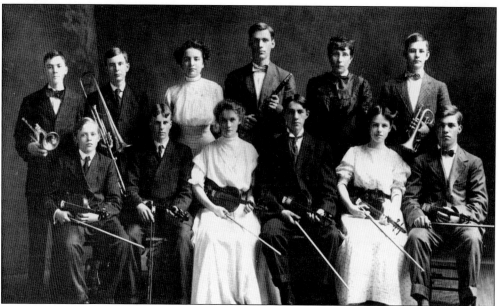

Over the years extracurricular activities have been an integral part of student life at the high school. Sports have played an especially prominent role in the history of the school, but other activities have had their place as well, as shown in this portrait of the dignified members of first orchestra at Champaign High School.

Even when new snow had muffled Main Street, one can see how automobiles had changed the face of downtown by the 1930s. Looking west, one can see Joseph Kuhn and Son on the right and other familiar buildings in the distance. Like other American cities, Champaign suffered through the Great Depression, but the nearby University of Illinois softened some of the economic difficulties of that period.

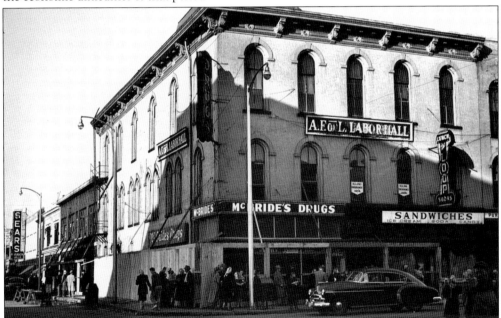

For many years the Labor Hall building in which Swannell's had been housed had long remained a landmark of downtown Champaign. Located the northeast corner of Hickory and Main Streets, the building housed McBride's Drugstore, a sandwich shop, and other businesses when noted local photographer Charles Webster made this photograph in March 1950. Note the Sears store just down the street on the left.

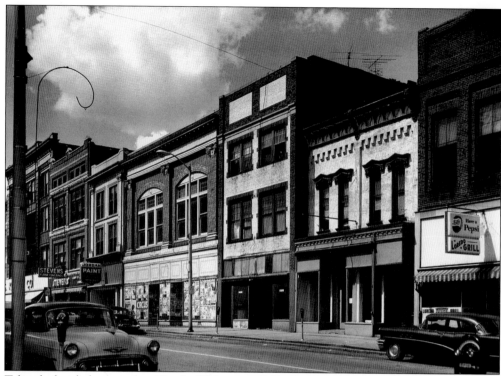

Taken by local photographer Charles Webster in 1952, these two photographs show Main Street looking east from the area of the railroad station from two somewhat different vantage points. The Illini Theatre, long a local landmark, appears along with other businesses that have long since been vanished on the changing face of this major city street. Otherwise the buildings and the layout of this key block of downtown Champaign appear remarkably familiar.

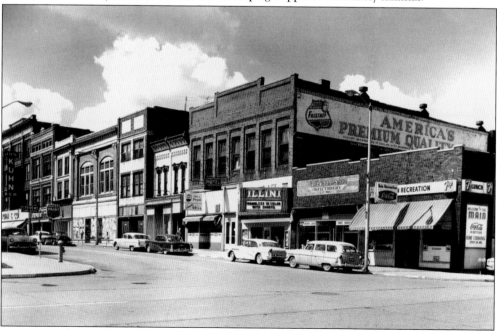

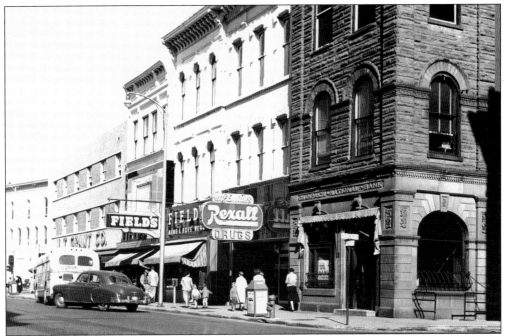

Another Charles Webster photograph of Main Street at the corner of Fremont Street, made about 1950–1952, offers a rare glimpse of downtown Champaign, including the ornate Champaign National Bank building, the Rexall drugstore, Field's clothing store, and W. T. Grant department store. This block has since been changed dramatically by fire and new construction.

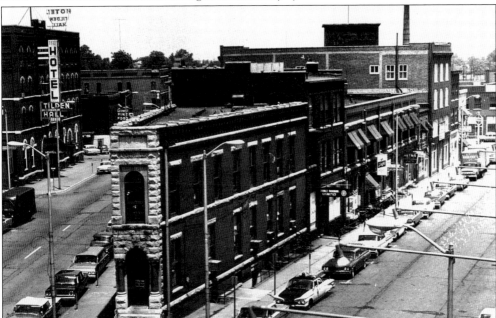

For many years, the flatiron building was a familiar sight at the intersection of Neil and Walnut Streets, as shown in this Charles Webster photograph from 1963. Although the intersection where the two streets sharply split is still quite familiar to Champaign residents, the landmark building has since been razed to make way for other commercial ventures and parking lots.

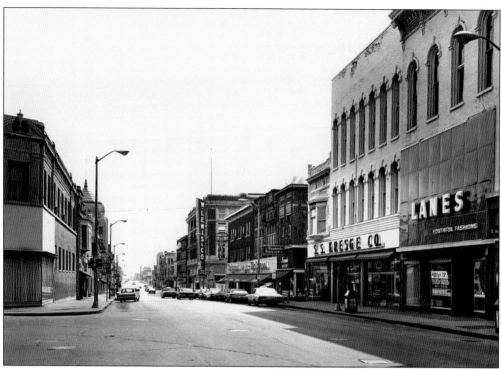

Two photographs of Neil Street, taken by Charles Webster in 1969, show how this central thoroughfare has changed in the past quarter century. In one photograph taken from a vantage point near Church Street, one can see that not only Lewis Department Store but also Kresge's and Lanes fashions have since vanished from the downtown streets. In the other image, one can catch a glimpse of Julie Ann Fabrics at its corner location.

University Avenue has long been the key thoroughfare in the twin cities, and when the Cattle Bank prospered, the First Street corner was the commercial center for West Urbana. Although shops still occupy the intersection, most of the retail activity shifted to the west side of the tracks. This Charles Webster photograph of 1962 shows the old Cattle Bank before its restoration when Heimlich Sundries occupied the building.

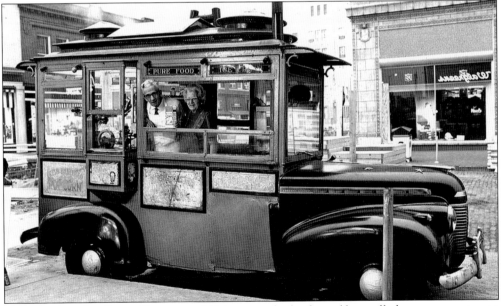

In 1919, when the Cretor Company of Chicago made the first self-propelled popcorn wagon on a Model T chassis, Henry Sansone bought one. In 1920, he married Lucille Boots, reputedly "for his popcorn," and the couple operated their wagon for more than 40 years in front of the old Kresge store until the Neil Street mall was constructed.

www.arcadiapublishing.com

Discover books about the town where you grew up, the cities where your friends and families live, the town where your parents met, or even that retirement spot you've been dreaming about. Our Web site provides history lovers with exclusive deals, advanced notification about new titles, e-mail alerts of author events, and much more.

Arcadia Publishing, the leading local history publisher in the United States, is committed to making history accessible and meaningful through publishing books that celebrate and preserve the heritage of America's people and places. Consistent with our mission to preserve history on a local level, this book was printed in South Carolina on American-made paper and manufactured entirely in the United States.

This book carries the accredited Forest Stewardship Council (FSC) label and is printed on 100 percent FSC-certified paper. Products carrying the FSC label are independently certified to assure consumers that they come from forests that are managed to meet the social, economic, and ecological needs of present and future generations.

Mixed Sources
Product group from well-managed forests and other controlled sources

Cert no. SW-COC-001530
www.fsc.org
© 1996 Forest Stewardship Council

Find Your Place in History.